JAMAICA PLAIN
THROUGH TIME

ANTHONY M. SAMMARCO

CONTEMPORARY PHOTOGRAPHS BY PETER B. KINGMAN

AMERICA
THROUGH TIME®
ADDING COLOR TO AMERICAN HISTORY

This book is dedicated to Henry F. Scannell Research Librarian
Extraordinaire, Retired Boston Public Library

Cover photo: Looking from South Street towards Centre Street in 1910, the Loring Greenough House is an elegant mid-18th century house. On the left is the Greenough Apartment Building designed by Arthur Wallace Rice and built in 1897 by the Jamaica Plain Associates. With mature trees framing the Civil War Monument, the bucolic aspect of Jamaica Plain at this time was highly evident. West Roxbury had seen 720 men serve in the Civil War and this impressive monument dedicated in 1871 memorializes the twenty three fellow citizens who lost their lives.

America Through Time is an imprint of Fonthill Media LLC
www.through-time.com
office@through-time.com

Published by Arcadia Publishing by arrangement with Fonthill Media LLC
For all general information, please contact Arcadia Publishing:
Telephone: 843-853-2070
Fax: 843-853-0044
E-mail: sales@arcadiapublishing.com
For customer service and orders:
Toll-Free 1-888-313-2665

www.arcadiapublishing.com

First published 2020

Copyright © Anthony M. Sammarco 2020

ISBN 978-1-68473-005-6

Typeset in Mrs Eaves XL Serif Narrow
Printed and bound in England

CONTENTS

ACKNOWLEDGMENTS

Joel Andreasen; Boston Fire Historical Society; Boston Public Library, David Leonard; Oliver Bouchier and Daria Regan; Brady & Fallon Funeral Service Inc.; Anne Lee Brewer; Hutchinson and Pasqualina Cedmarco; Cesidio "Joe" Cedrone; the late Frank Cheney; Boston Children's Museum, Carole Charnow, president, and Jo-Anne Baxter; Christ the King Church, Very Rev. Archpriest Yaroslav Nalysnyk, Pastor; Elise Ciregna; City of Boston, ISD, Brigid Kenny-White; Edie Clifford; Colortek, Jackie Anderson; Jean Degnon; Dennis J. De Witt; William Dillon; eBay; Eliot School, Abigail Norman; the Faulkner Hospital; First Church in Jamaica Plain Unitarian Universalist, Rev. Elizabeth Bukey; Forest Hills Cemetery, George Milley, Janice Stetz and Shelbi Freeman; the late Herbert and Jane Gorman Forsell; Greg French; Goddard House, Lance A. Chapman, assistant executive director; Edward Gordon; Katherine Greenough; Theodore C. Haffenreffer; Bud and Betty Hanson; Lee Harvey; Elaine Hemenway; Mary Dunn Hern; Edgar B. Herwick III; Historic New England, Lorna Condon; Kathy Hourihan; the Italian Home for Children, Daniel Brennan; Jamaica Plain Branch, Boston Public Library; Jamaica Plain Historical Society; Jamaica Plain Neighborhood Development Corporation, Richard Thal, JPNDC executive director; the late Nils Johnson; George Kalchev, Fonthill Media; Peter Bryant Kingman; the Loring Greenough House, the Jamaica Plain Tuesday Club; John Franklin May; The Monastery of St. Clare, Sister Clare Frances McAvoy, O.S.C.: MSPCA, Rob Halpin, Director of Public Relations; Frank Norton, with many thanks for the use of his archives; Orleans Camera; Charlie Rosenberg and Fran Perkins; Anthony Ristuccia; St. Thomas Aquinas Church, Father Carlos Flor; Henry Scannell; Ron Scully; the Lemuel Shattuck Hospital; Maureen Smith; Alan Sutton, Fonthill Media; Jon Truslow; Utile; Martha Verdone, Copeland Foundation; the Vincent Memorial Hospital; West Roxbury Division, Boston Municipal Court, Hon. Kathleen E. Coffey, First Justice; Elizabeth Shaw Williams.

Unless otherwise noted, photographs are from the Boston Public Library.
Photographs used in this book will be donated to the Archives and Special Collections, Healey Library, University of Massachusetts at Boston.

INTRODUCTION

Jamaica Plain is the Eden of America

Known in the seventeenth and eighteenth centuries as the Jamaica End of Roxbury, the neighborhood of Jamaica Plain, Massachusetts, has evolved from agrarian farmland into one of the more dynamic and inclusive neighborhoods of twenty-first-century Boston. Settled in 1630 by Puritans from England, and a part of the Town of Roxbury until 1851 and then of the Town of West Roxbury until 1874, Jamaica Plain began to evolve with the development of the Stony Brook, which yielded power for mills and factories and numerous breweries that created a thriving economy.

However, by the nineteenth century, Jamaica Plain was to become one of the earliest streetcar suburbs of Boston with ease of transportation linking it to downtown Boston. Stagecoaches had long connected Boston and Providence, Rhode Island, along Centre Street, then known as the Highway to Dedham, and Washington Street, known after 1806 as the Norfolk and Bristol Turnpike. However, in 1826, "hourlies," horse drawn omnibuses, connected Jamaica Plain to Boston on a regular schedule, and by the mid-1830s larger omnibuses were necessary to provide increased transportation for residents. A train line connecting Boston and Providence, Rhode Island, was laid out by Henry A. Whitney in 1834, and the Boston & Providence Railroad began service, with special "commuter fares" offered to residents of Jamaica Plain in the years just prior to the Civil War. Passenger depots at Boylston Street and at Tollgate, the present-day Forest Hills Station, were to provide not just increased transportation but would also spur on residential development. A depot at Green Street was later opened at the request of residents which continued unabated residential development in Jamaica Plain in the 1850 to 1890 period.

Green Street was laid out in 1836 to connect Centre Street and Washington Street and would become a hub of local artisans and builders. Soon after, Centre Street near Green Street became the local main street, with shops, grocers and dry goods stores attracting local business providing products from the West Indies and common household goods. During the mid-nineteenth century, as commuters from Boston began to settle in Jamaica Plain, the local market grew, with businessmen providing much of the needed products and services. In the Stony Brook Valley along the railroad line adjacent to Roxbury, a small industrial center formed, with small chemical factories, tanneries and soap factories taking full advantage of the power afforded by the Stony Brook with

the access to transportation for employees. Reflecting the dramatic population growth, a number of new churches of diverse denominations were built serving the new—and more varied ethnically as well as religiously—diverse community.

By 1850, the once agricultural community had seen a significant shift in its population with businessmen and professionals beginning to supersede farmers and the beginnings of immigrants moving to the neighborhood. With an effort to stem the increase in property taxes to support the rapidly urbanizing inner Roxbury area, the owners of the large estates in Jamaica Plain led a successful effort in 1851 to secede from the city of Roxbury and form a new, suburban town to be known as West Roxbury. Meanwhile, population growth, increasing by both matriculation as well as by immigration, continued steadily. In the 1850s, David Greenough developed the south section of his estate into four streets and shortly afterwards he sold land along the east side of the railroad tracks for the new Jamaica Plain Gas Light Company. In 1857, the new West Roxbury Railroad Company extended their streetcar line to a depot on South Street, at the site of today's public housing development.

When Jamaica Plain was annexed to the City of Boston in 1874, along with West Roxbury, Roslindale, Brighton, Allston and the city of Charlestown, the rate of growth continued unabated. The three-decker house, a defining style in urban New England architecture, was built in the late 1880s and spread rapidly by the turn of the twentieth century, increasing the housing stock in the community. In Jamaica Plain, the first commercial blocks were built in the 1870s and in 1873, the imposing Ruskinian Gothic style police station was built on Seaverns Avenue. In 1874, the recently built Eliot School was renamed the West Roxbury High School, only to be changed to the Jamaica Plain High School after annexation. The Stony Brook Valley had long been the industrial center of Jamaica Plain. In 1871, the Haffenreffer Brewery opened near Boylston and Amory Streets, taking advantage of the Stony Brook aquifer and the large number of German immigrants in the area who would be employed in the numerous breweries. The same year, the Boylston *Schul Verein* German social club opened just across the railroad tracks, and was one of many organizations that served German residents in the neighborhood. The B. F. Sturtevant Company opened an industrial fan factory in 1878 along the railroad tracks between Williams and Green streets, which grew to employ 500 employees

The plethora of breweries in Jamaica Plain continued to be major employers during the nineteenth and twentieth centuries. On Heath Street, the Highland Spring Brewery had been operating since 1867, and in the 1880s, the Eblana and Park Breweries and the American Brewing Company opened, employing local German and Irish immigrants to fill jobs. The Franklin Brewery extended the beermaking district to Washington Street. These and other breweries were all closed during Prohibition, and few survived to reopen after repeal, although many found other uses, and some were repurposed as condos and commercial space. An exception was the Haffenreffer Brewery, which continued until 1964. The former brewery now houses a number of commercial establishments, including the Boston Beer Company, brewers of Samuel Adams beer. A notable company that moved to Heath Street after prohibition was the Moxie Soft Drink Company. Invented

by Augustin Thompson in Lowell, Massachusetts, in 1876, the company marketed the distinctively flavored Moxie to shift it from medicinal "tonic," as it was known, to a soft drink, much like Coca-Cola, which it outsold in the 1920s. The company stopped advertising their distinctive product during the Great Depression, and it never was able to recover their lost market. After the Moxieland Plant closed in 1953, it was torn down by the City of Boston for the new Bromley Heath Housing Development.

During the late nineteenth century, Jamaica Plain's housing stock grew with the commercial development, providing homes for workers in local businesses and well as commuters to town. Sumner Hill, based on the old Greenough estate, became home to business owners and managers and in the 1880s, the Parley Vale estate and Robinwood Avenue were developed to serve the same market. Ten years later, Moss Hill Road and Woodland Road were laid out on land owned by the Bowditch family, creating Moss Hill, one of the most exclusive neighborhoods in Jamaica Plain until this day. At the same time, the land off South Street was being developed into streets and filled with houses for the working-class population. By the early twentieth century, most of the streets of Jamaica Plain were laid out, and houses or businesses occupied most buildable lots. The erection of the Boston Elevated Railway was a major factor in ease of transportation in the twentieth century, and in order to avoid accidents at street crossings it was built from Roxbury south through to Forest Hills station, and offered access to downtown Boston in fifteen minutes.

By the early twentieth century, Jamaica Plain was not just a residential neighborhood but also one of institutions, hospitals and schools, many of which were renowned throughout New England. There were the Faulkner, Washington, Shattuck, Vincent Memorial, Massachusetts Osteopathic and the Veterans Administration Hospitals; the New England Home for Little Wanderers and the Trinity Church Home; the Boston School of Physical Education, the Eliot School, the Perkins School for the Blind and the Nursery for Blind Babies; the Massachusetts Society for the Prevention of Cruelty to Animals and the Children's Museum all added to the clubs at the turn of the century—the Jamaica Club, the Boylston *Schul Verein* German social club, the Tuesday Fortnightly Club and Eliot Hall. Each of these vitally important organizations made Jamaica Plain a destination that served the needs of not just Bostonians but New England.

In the late nineteenth century, Boston's Emerald Necklace was designed and laid out by Frederick Law Olmsted, continued by Olmstead, Olmstead and Eliot, with much of the southern section of the connecting parkland in or bordering on Jamaica Plain. Olmstead Park, Jamaica Pond, the Arnold Arboretum and Franklin Park have been enjoyed by generations of Jamaica Plain residents. The banks of Jamaica Pond had long been the site of estates, which were removed to make the new park. Fishing and ice skating were popular pastimes, and each winter ice was removed from the pond for iceboxes before the time of electric refrigeration. The Arnold Arboretum was developed on land originally owned by the Weld family, and donated by Benjamin Bussey, with financial support from the will of James Arnold. The Arboretum is now owned by the City of Boston, and managed by Harvard University. With this Emerald Necklace, Jamaica Plain is truly the Eden of America.

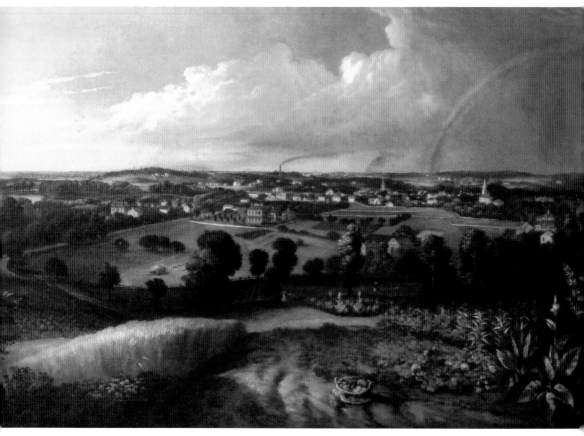

The bucolic estate of Captain Charles Brewer (1804-1885) was depicted in 1850 by Boston artist Henry Cheever Pratt with the Brewer House seen in the center just to the right of Jamaica Pond. Brewer made a fortune supplying whaling ships with general merchandise and later investing in Hawaii's sugar cane industry, eventually becoming one of Hawaii's Big Five companies. On the far right is the spire of the Third Parish in Roxbury Meetinghouse at Centre and Eliot Streets. [*Courtesy of Anne Lee Brewer*]

1

EARLY JAMAICA PLAIN

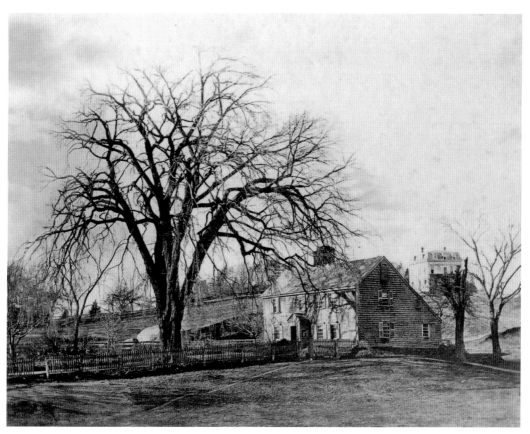

The Curtis House was built in 1639 by William and Sarah Eliot Curtis at what is now the corner of Lamartine and Paul Gore Street. By the mid-nineteenth century, the venerable First Period house which had sheltered the eight generations of Curtis descendants had become a local landmark. However, the encroachment of residential and commercial development and increased land value precluded that the demolition of the house in 1887 would allow the area to be developed and new houses to be constructed. [*Courtesy of Greg French*]

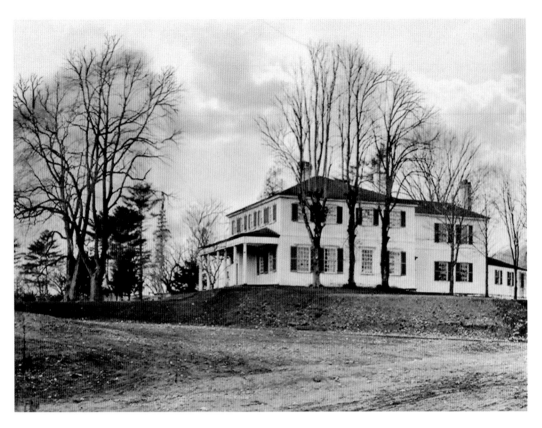

Bromley Vale was the fourteen-acre country estate of the illustrious Lowell Family on the Roxbury-Jamaica Plain line. John Amory Lowell (1798-1881) was a wealthy merchant, Fellow of Harvard College and trustee of the Lowell Institute, and he maintained an extensive farm where he experimented in horticulture as a gentleman farmer. The estate had three greenhouses, a windmill and a folly—a tower of a ruined castle, which replicated in a far smaller scale the great English estates. It was once between Centre and Heath Streets and it today the Bromley Heath Housing Development, designed by Thomas F. McDonough and constructed in 1952.

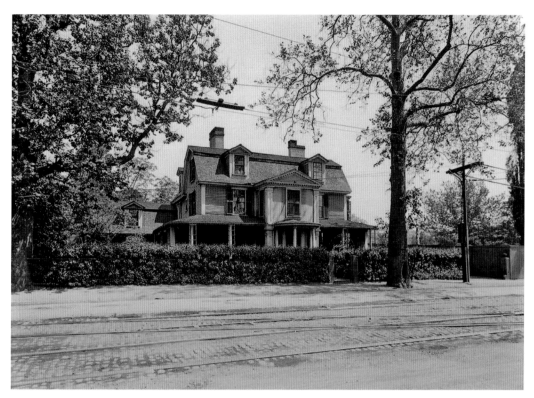

The Hallowell House was built in 1738 at the corner of Centre and Boylston Streets. The home of Benjamin Hallowell, who was a Loyalist and left Boston with the British troops in 1776, it was later owned by Ward Hallowell (1749-1828,) later to be known as Ward Nicholas Boylston, a man noted for his "liberality [that] was commemorated by a school, a market and a street" in Boston. The house was demolished in 1924 and a one-story commercial block was built; today, Zesto's Pizza and Grille, Panaderia Los Gemelos and the Acapulco Restaurant are now on the site.

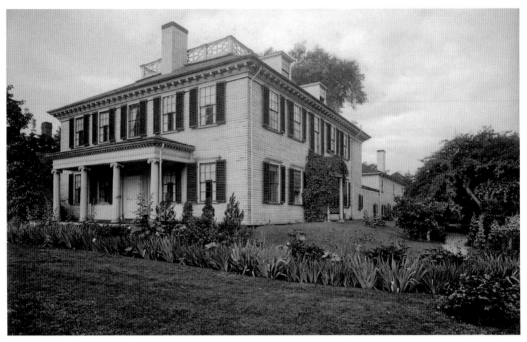

The Loring Greenough House was built in 1760 and is located at the junction of South and Centre Streets, both of which were laid out in 1662, and which was once the home of Joshua Loring, a British Naval officer and a Loyalist who left Boston in 1776. Later the home of Ann Doane and David Stoddard Greenough, the house was remodeled with an Ionic columned porch and a carriage house; the grounds were beautifully landscaped with the family living here until 1924. Now maintained by the Jamaica Plain Tuesday Club, it has been placed on the National Register of Historic Places.

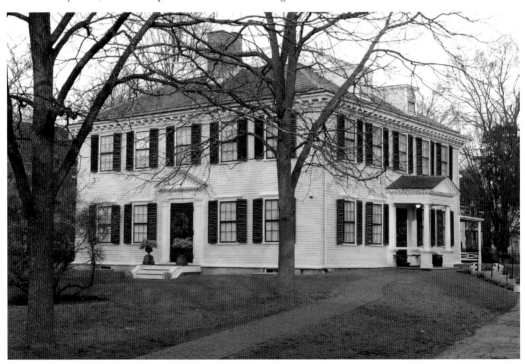

The Weld House was built at the corner of Centre and Westerly Streets opposite what is now Wyman Street. The Weld Family descended from Captain Joseph Weld, who fought in the Pequot War in 1637 and was granted 278 acres in Roxbury for his service; the Weld property is now much of present-day Jamaica Plain and Roslindale. With the wealth generated from this tremendous land grant, Joseph Weld became an early donor to Harvard College and a founder of the Ancient and Honorable Artillery Company of Massachusetts. This house was built in the early nineteenth century and is now the site of the Christian Science Reading Room and the Old Havana Cuban Restaurant.

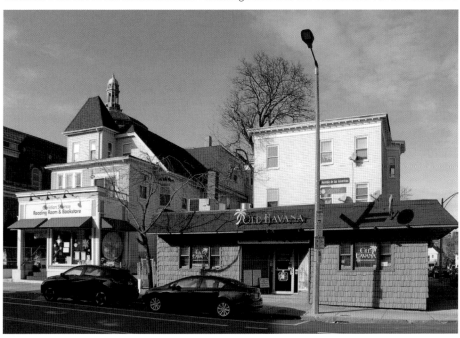

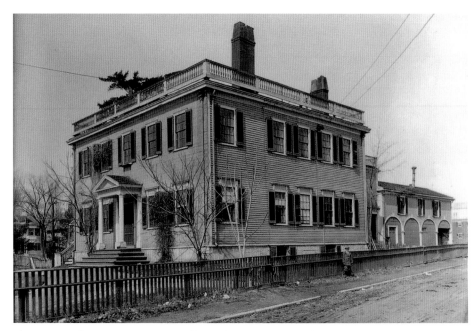

The Moses Williams House was at 821 Centre Street between Aldworth and Dunster Streets. Since 1812, Moses Williams (1790-1882) and John D. Williams were importers of Wines, Spirits, Teas, and Cigars. Known as J. D & M. Williams, "They were business men of signal ability, enterprise, and push, and were accounted among Boston's foremost and most progressive merchants, importer of the famous *Roderer's* and *Schreider's* champagnes ... and of a quality that commends them to all judges of champagne wines ... [and] also deal in the most famous vintages of French brandies, in Scotch and Irish whiskies, gins, rums and *liqueurs."* They also dealt in the choicest old and mellowed brands of rye and bourbon whiskies; while his stock of choice Havana cigars are goods far superior to what is termed the best elsewhere. A large apartment building is now on the site.

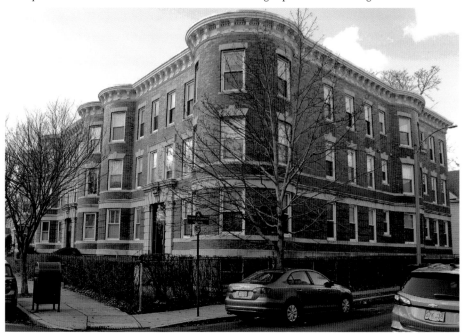

The Curtis-Spooner House was built at 480 Centre Street opposite Pershing Road on a small lot with its side to the street. A Federal five bay facade house with corner quoining and a low hipped roof, it is an early nineteenth century house once associated with the Curtis Family. The house was later owned by William H. Spooner (1823-1906) who was a noted horticulturalist and president of the Massachusetts Horticultural Society from 1890 to 1892; he cultivated "Spooner's Hardy Garden Roses" in his renowned nursery on the adjacent lot, now a commercial block with 482 Hair Studio, Ideal Café & Pizza, PS Nail & Spa and Streetcar Wine and Beer.

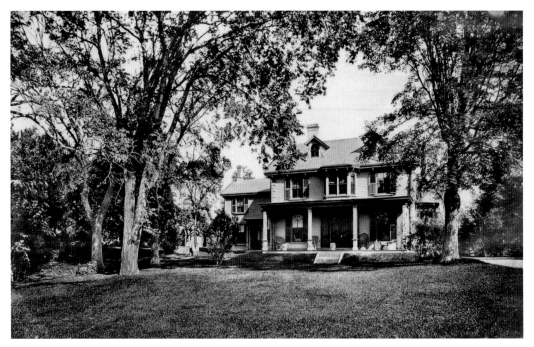

The Ellicott House was built as a summerhouse by Joseph Porter Ellicott (1819-1901,) a partner of Edward D. Peters in Davenport & Peters Company, and was located on an edge of what would become Franklin Park at Forest Hills Street. John Charles Olmstead of Olmstead, Olmstead and Eliot would design in 1889 the Ellicott Arch of large stone boulders planted with vines and creepers that marks the original location of the house, and which led to Ellicottdale where lawn tennis and croquet was enjoyed. Circuit Drive was designed for carriage traffic with foot traffic on the lower road.

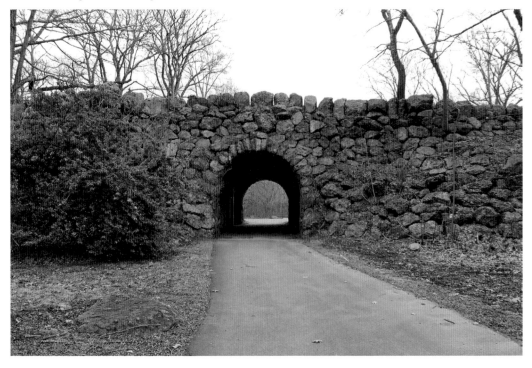

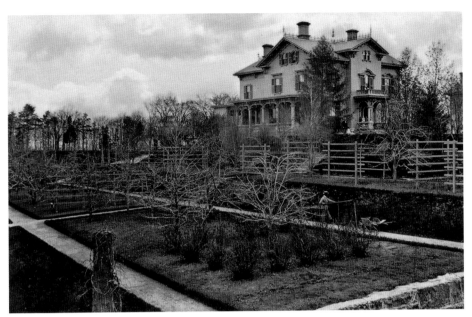

Seen in 1880, the Judge Benjamin Franklin Thomas House was at 111 Perkins Street and was a large Italianate mansion with fabled gardens; Thomas ascribed to "the opinion of [Francis] Bacon, that a garden is the purest of human pleasures, and the greatest refreshment to the spirits of man." Henry H. Reuter, who bought the house in 1874, was a partner with John R. Alley in Reuter & Alley, known as the Highland Spring Brewery, which brewed ale from 1867 to 1885 at Heath and Parker Streets and in 1876 won a gold medal at the Philadelphia Centennial Exposition. This was one of many breweries along the Stony Brook in Jamaica Plain. The house is now the site of the thirty-story Jamaicaway Tower and Townhouses overlooking Jamaica Pond from Perkins Street.

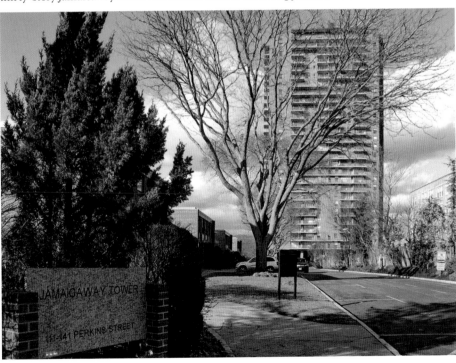

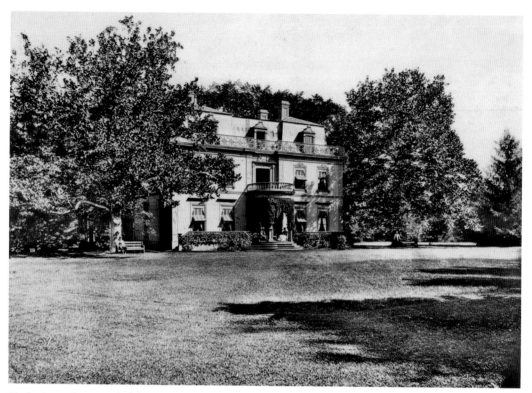

Pinebank was the second of three successive Perkins Family mansions and was built in 1848 on the edge of Jamaica Pond on a small spit of land accessed from Perkins Street opposite Ward's Pond. Designed by the noted French architect Jean Lemoulnier for Edward Newton Perkins, the son of China Trade merchant James Perkins, it was a refined villa of the *deuxieme classe* with a Mansard roof. The house was destroyed by fire in 1868 and a new mansion was built which was later sold to the Boston Park Commission in 1892, and after which it served as office headquarters until 1913 when it became the first location of the Children's Museum.

2

ALONG CENTRE STREET

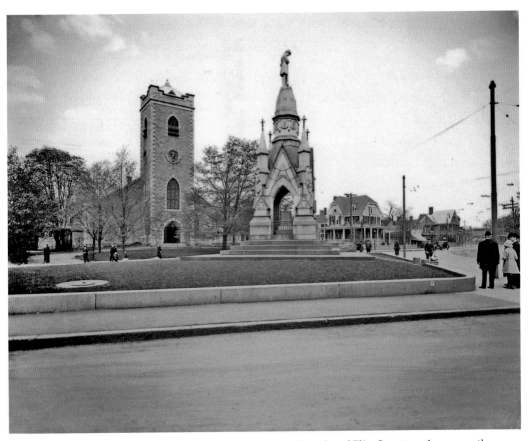

Monument Square is the junction of Centre, South, Holbrook and Eliot Streets and was once the site of the local schoolhouse until 1831 when it was moved to Eliot Street. The Civil War Monument was erected in 1871 in memory those men of West Roxbury (which at that time included both Roslindale and Jamaica Plain) who gave the supreme sacrifice in the Civil War 1861-1865. The facade and crenelated tower of the First Church of Jamaica Plain can be seen in the distance, and large houses can be seen on the right along Centre Street just past Eliot Street before the encroachment of commercial blocks.

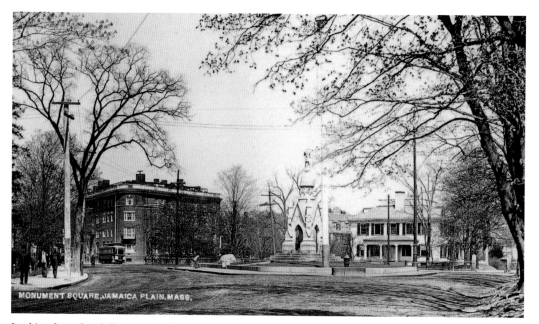

Looking from South Street towards Centre Street in 1910, the Loring Greenough House is an elegant mid-eighteenth-century house. On the left is the Greenough Apartment Building designed by Arthur Wallace Rice and built in 1897 by the Jamaica Plain Associates. With mature trees framing the Civil War Monument, the bucolic aspect of Jamaica Plain at this time was highly evident. West Roxbury had seen 720 men serve in the Civil War and this impressive monument dedicated in 1871 memorializes the twenty-three fellow citizens who lost their lives. The Monument Square Historic District was added to the National Register of Historic Places in 1990.

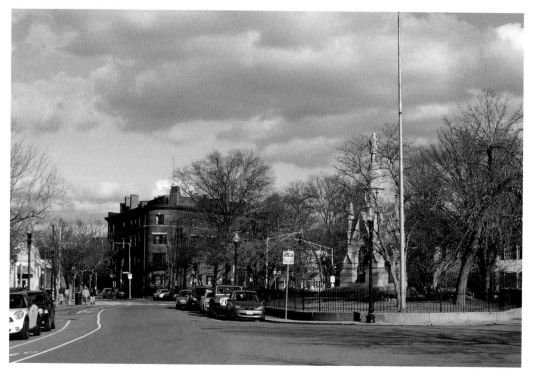

Seen in the mid-twentieth century, the Civil War Monument had been designed by William W. Loomis and is of an impressive Gothic design. Built of both Quincy and Clark's Island granite, it had four pinnacles that are ornamented with carved groups of military trophies and bronze finials. There are four panels above the arches with the immortal names of Lincoln, Andrew, Thomas and Farragut. The monumental thirty-four-foot memorial is surmounted by a soldier leaning in a pensive attitude upon his musket by sculptor Joseph Sala. [*Courtesy of Frank Norton*]

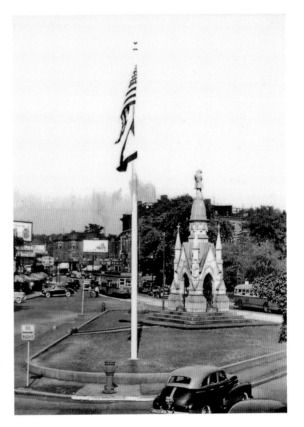

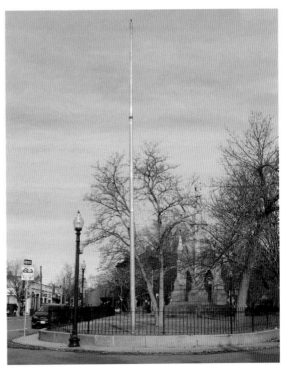

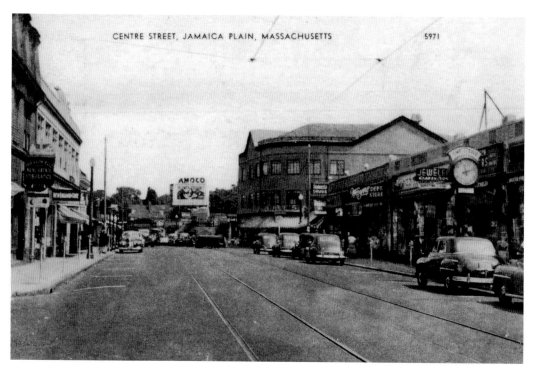

Centre Street, with Burroughs Street on the left and Seaverns Avenue on the right, had become the shopping district of twentieth-century Jamaica Plain before the advent of shopping malls. The Masonic Building, now City Feed and Supply, with Kennedy Butter & Eggs and the Clothes Inn on the ground floor, is in the center and on the right a one-story commercial block with Richard's Drug Store, Wayne Department Store, McLaren & Son Jeweler and a street clock proclaiming "Time to Save." Later, the stores were Hailer's Pharmacy, F. W. Woolworth Co., Publix Market and the Jones Card Shop.

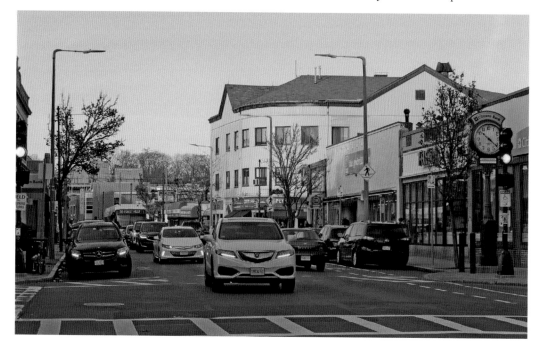

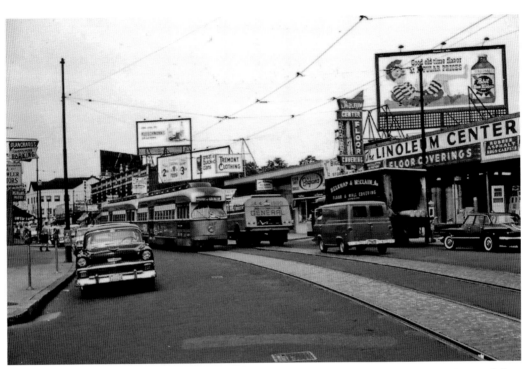

Centre Street, since it was laid out in 1662, has always had steady traffic as it is a major conduit to Brookline and Roxbury and points further beyond. On the right, opposite Burroughs Street, is Tremont Clothing, Brigham's and The Linoleum Center. Today, this block has CVS, the Galway House, Boomerang's, Titan Insurance and Scanlan Physical Therapy. [*Courtesy of Frank Norton*]

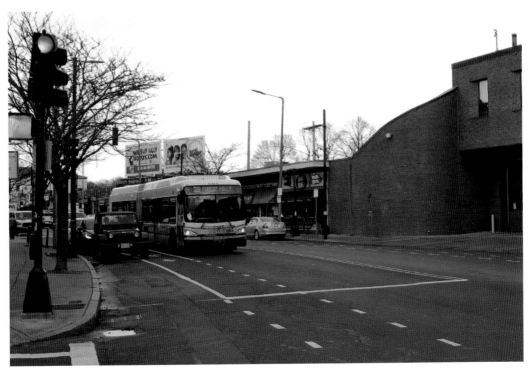

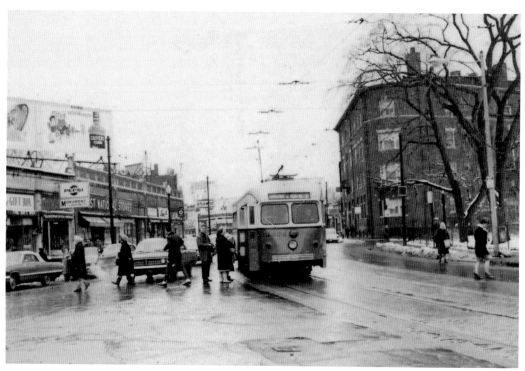

Centre Street at South Street, on the left, has a one-story commercial block with small businesses including Jamaica Drug Store, Monument Fruit, Fairview Driving School, The Gift Box, the Monument Luncheonette and a First National Store. On the right is the Greenough Apartment Building designed by Arthur Wallace Rice and built in 1897 at the corner of Greenough Avenue. Today on the left are REPS Fitness, Soup Shack, American Dry Cleaners, JP House of Pizza, AAA Appliances, Expresso Yourself and Salmagundi. [*Courtesy of Frank Norton*]

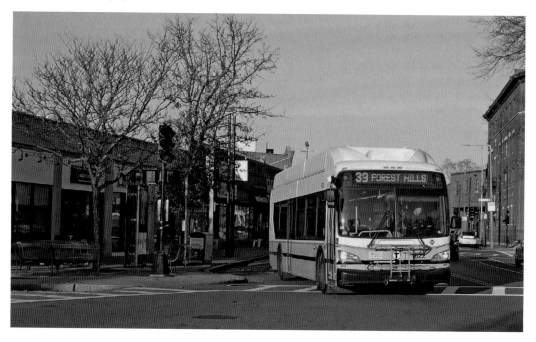

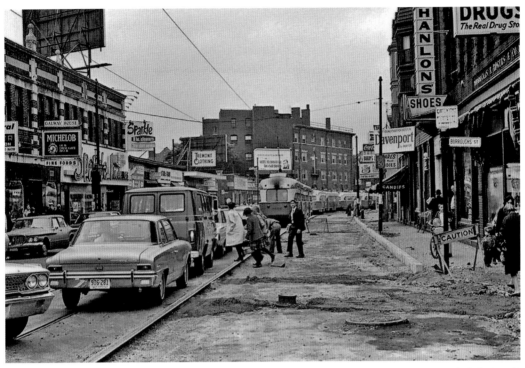

Center Street, seen at the corner of Burroughs Street while being repaved in 1967, had on the left Harry's Hardware Store, the Galway House, Sparkle Cleaners, Yankee Cleaners, Dr. Sanderson Optometrist Office, Star and Rand, Tremont Clothing and Hennigan Insurance and Real Estate. On the right in the Fallon Block was the C. B. Rogers & Company Druggists and Hanlon's Shoes. In the distance is the Greenough Apartment Building. [*Courtesy of Frank Norton*]

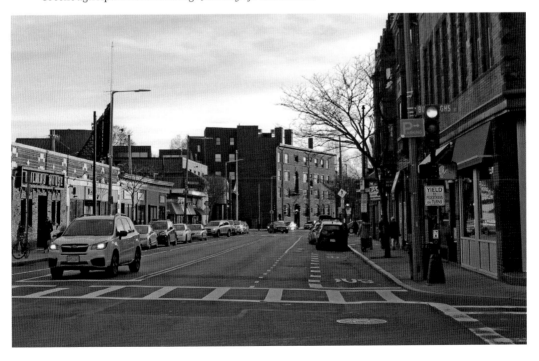

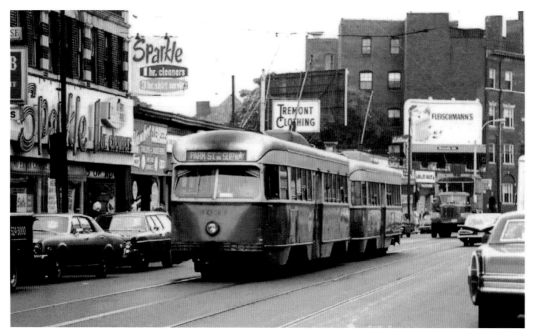

Built on the site of the Jamaica Plain Universalist Church, this commercial block on Centre Street had the Galway House, Sparkle Cleaners, Yankee Cleaners, Tremont Clothing, Centre Toy Shop, Allied Wallpaper, Mullen's Bakery and the Typewriter & Adding Machine Co. This was the shopping district before the ascendancy of the automobile and the shopping malls in post-World War II America. Today the Boston Fire Engine 28, Tower Ladder 10 is on the site. [*Courtesy of Frank Norton*]

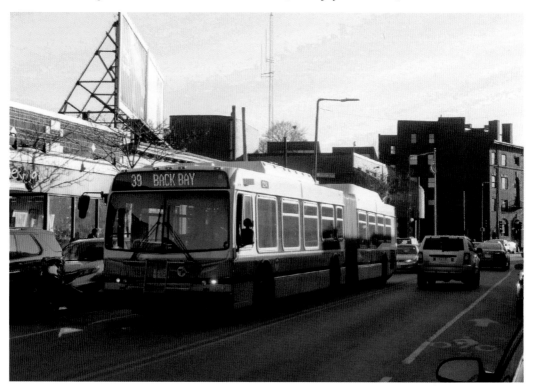

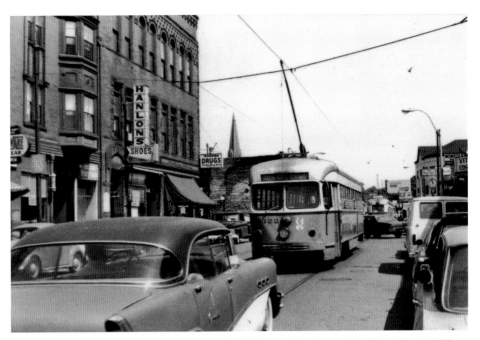

Seen in the 1960s, the Rooney Block, designed by H. Henry Winslow and built in 1887 for William Rooney, and the Fallon Block designed by George A. Cahill and built in 1888 at the corner of Burroughs Street, had shops on the first floor with a hardware store, a barber shop and beauty salon, Hanlon's Shoes and C. B. Rogers & Company Druggists. Streetcar No. 3322 connected Park Street in Boston with Forest Hills Station, and was a major transportation route in the city via Centre Street. In the distance can be seen the spire of the Jamaica Plain Baptist Church. [*Courtesy of Frank Norton*]

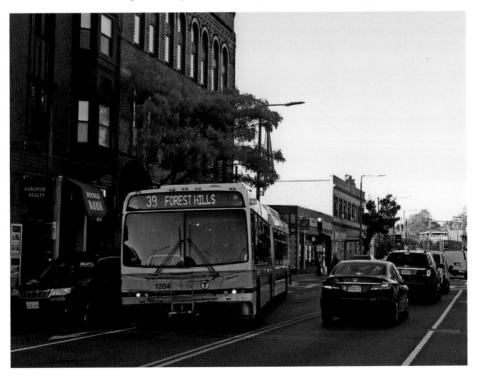

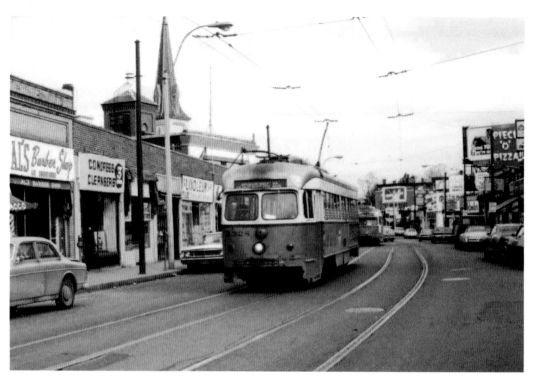

This stretch of Centre Street had Al's Barber Shop, Congress Cleaners, the Jamaica Fruit Center and the Linoleum Shop. On the right is a sign for Piece O' Pizza, which was a favorite place for the Italian pizza pie. The spire seen above the façade of Engine 28, Ladder 10 Firehouse, Boston Fire Department (now J. P. Licks Ice Cream) on the left is that of the First Baptist Church in Jamaica Plain. [*Courtesy of Frank Norton*]

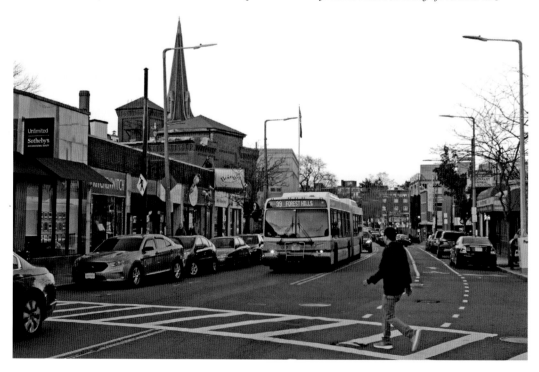

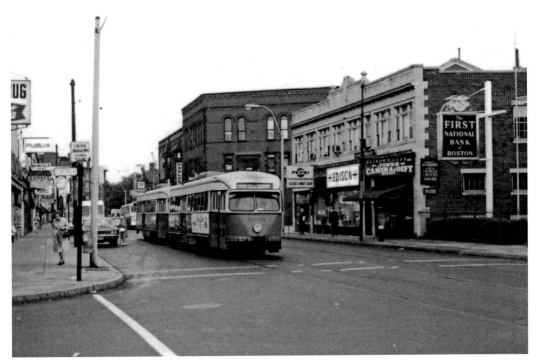

Centre Street at Seaverns Avenue in the 1970s had Helen's Donut Shop, the Boston Edison office and Jones Camera and Gift Shop on the first floor of the Centre Building, with professional offices on the second floor. On the far right was the First National Bank of Boston; in 1941 this branch of the First National Bank had the first drive up window for banking in the city. Today this is the Eastern Bank, Fire Opal and the Bank of America. [*Courtesy of Frank Norton*]

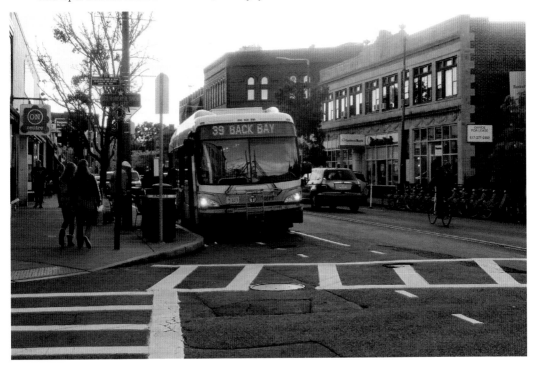

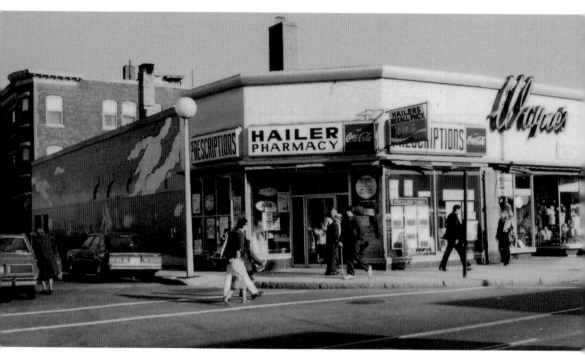

Hailer Pharmacy, operated by Fred C. Hailer, was at the corner of Centre Street and Seaverns Avenue. It was part of the Rexall Drug Chain associated with the federation of United Drug Stores from 1903 and licensed the Rexall brand name to as many as 12,000 drug stores across the United States from 1920 to 1977. Wayne's Clothing Shop is on the right and this was later the first site of J. P. Lick's Ice Cream and is now the Purple Cactus. On the left is a six-unit brick and granite apartment building at 9 Seaverns Street which is typical of the multi-family apartment buildings being built at the turn of the century. [*Courtesy of Frank Norton*]

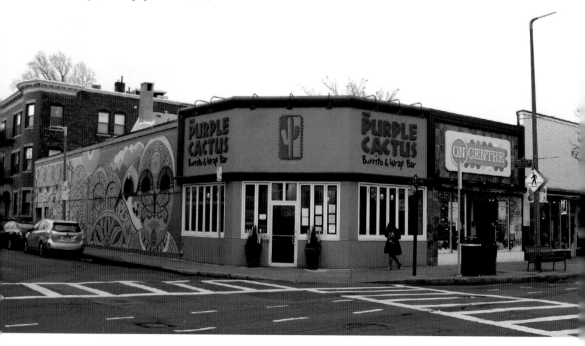

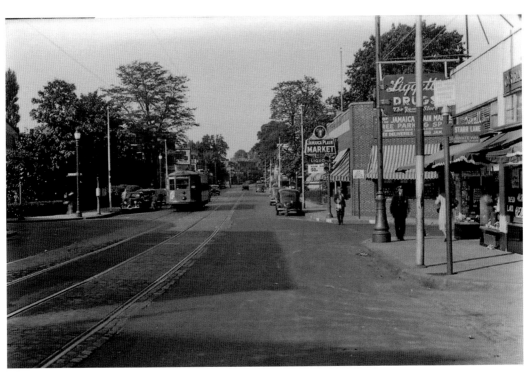

Centre Street between Green Street and Starr Lane had a one story commercial block that had Liggett's Drug Store, once a part of a chain founded by Louis Kroh Liggett, who also founded Rexall and served as chairman of United Drug Company, on the right, and this is now Classic Cleaners, which was founded in 1953. The Jamaica Plain Market at the corner of Green Street can be seen in the distance, now the site of the Southern Jamaica Plain Health Center. On the far right is the lawn of the First Baptist Church in Jamaica Plain. [*Courtesy of Historic New England*]

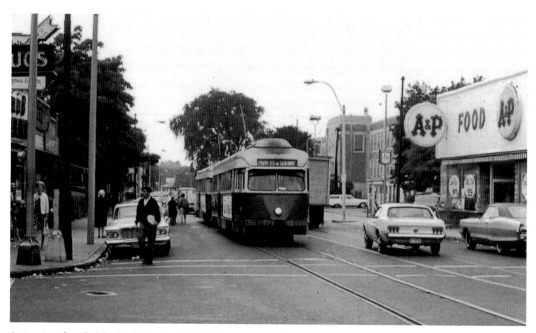

A streetcar headed for Park Street via the Subway approaches the intersection of Centre, Moraine and Boylston Streets in 1972. On the right is the A&P Market. Founded in 1859, A&P was to become the world's largest retailer, and in 1936 adopted the self-serve supermarket concept and opened 4,000 stores by 1950. A&P's decline began in the late 1950s, when it failed to keep pace with competitors that opened supermarkets with modern features demanded by customers. By the 1970s, A&P stores were outdated, and its efforts to combat high operating costs resulted in poor customer service; later Flanagan's Super Market and now CVS is located here today. On the left is Centre Drug Store and Hub Liquors, now the Acapulco Restaurant. [*Courtesy of Frank Norton*]

3

PLACES OF WORSHIP

Nehar Shalom Community Synagogue is located at 43 Lochstead Avenue in Jamaica Plain. *Nehar Shalom*, which means "river of peace," is the only Jewish place of worship in the neighborhood. The synagogue states: "Without airs, we offer immediately accessible community in which each person has the opportunity to make a difference. Exactly as you are, each person is recognized at Nehar Shalom as a learner and a teacher. We offer the opportunity for you to learn new skills. And hope that you will share yours."

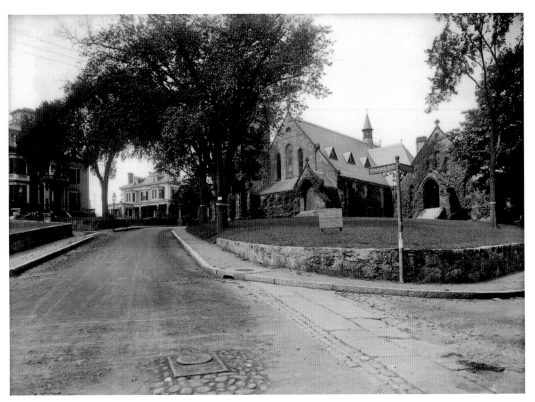

St. John's Episcopal Church, founded in 1841, was designed by Harris M. Stephenson and built in 1882 and consecrated in 1885 at Roanoke and Revere Streets on Sumner Hill. The land was donated by William Hyslop Sumner, for who Sumner Hill and the Sumner Tunnel was named, and the impressive English village style Roxbury Puddingstone church is set on a slight knoll adjected to houses built in the mid-nineteenth century.

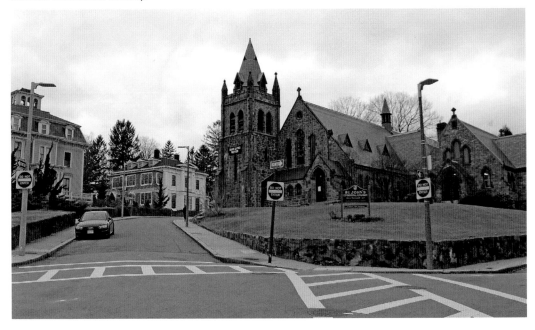

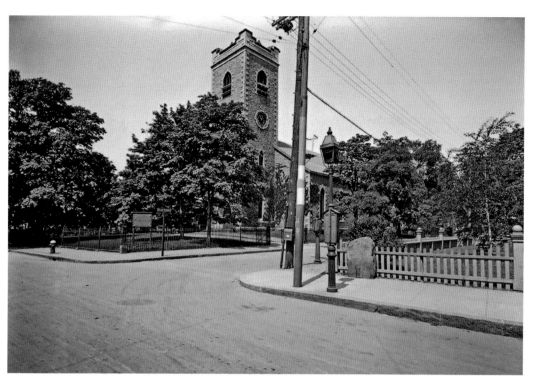

The First Church in Jamaica Plain was designed by Nathaniel J. Bradlee and built in 1854 at the corner of South and Eliot Streets. Originally known as the Third Parish in Roxbury and founded in 1769, it was the only church in Jamaica Plain until 1841. In 1853, the wood meetinghouse was replaced with an ashlar granite Gothic Revival church with a crenelated tower with a clock. In 1889, a Parish Hall was designed by Cabot, Everett & Mead and built to the rear of the church.

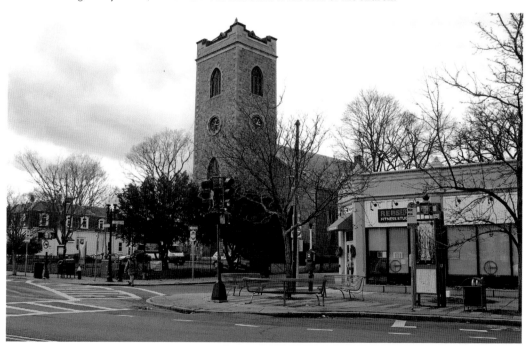

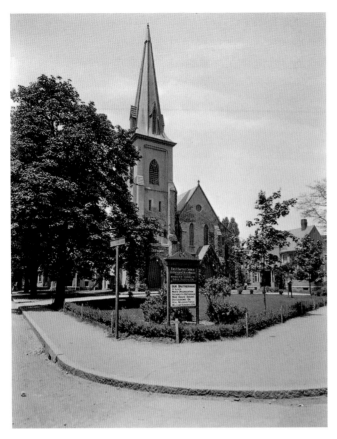

The First Baptist Church, founded in 1842, was designed by Ryder and Fuller and built in 1859 at the corner of Centre and Myrtle Streets. A large English Gothic Revival church with an asymmetrical bell tower, it was covered in stucco. A fire in 2005 destroyed the church nave and it was rebuilt and where the congregation has "sought the strength and energy of the Holy Spirit to guide our vision for ministry on this corner of Jamaica Plain."

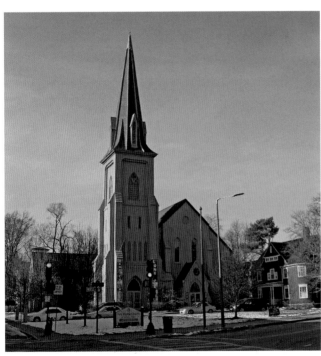

Central Congregational Church, founded in 1853, was designed by Allen, Collens and Willis and built in 1935 at 85 Seaverns Avenue to replace an earlier church from 1872 that had been destroyed by fire. An impressive high style Georgian Revival design with a belfry surmounted by a six-sided steeple, it commands the corner. The Hope Central Church, a co-joining of the Central Congregational Church and the Hope Church, now worships here. The Hope Central Church states that they are a "welcoming, diverse community of people, who could learn and grow together in faith, love, and joy."

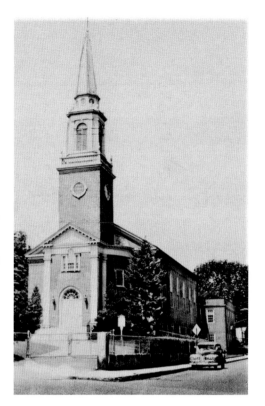

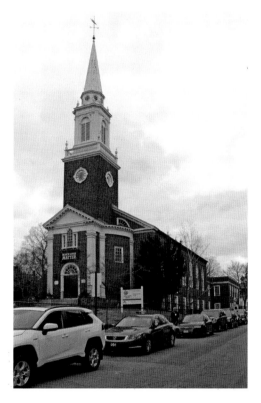

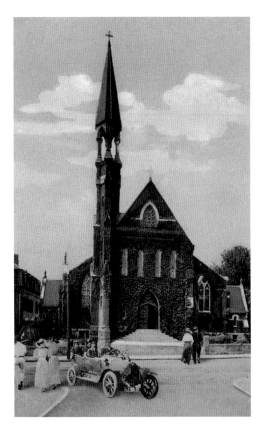

St. Thomas Aquinas Church was designed by Patrick J. Keeley and built in 1873 at the corner of South and St. Joseph Streets. The church was built of red brick with a stone foundation in the Gothic style with an asymmetrical bell tower. It was later remodeled in 1920 with the campanile and the entire facade pulled down and rebuilt with an entirely different design that was most likely done by Matthew J. Sullivan (1868-1948) who specialized in ecclesiastic architecture in the early twentieth century. The result was two buttressed towers, flanking an enormous stained-glass lancet window, surmounted by copper spires in the Art Deco style.

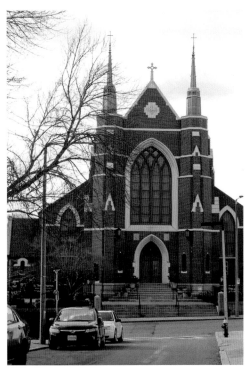

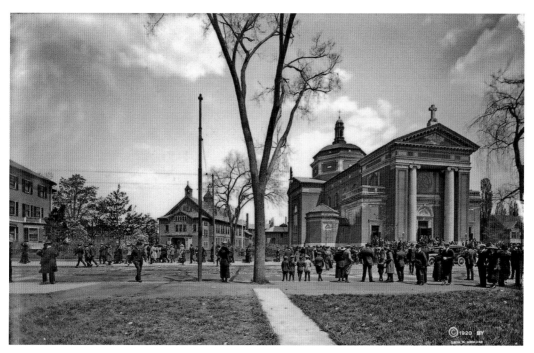

Blessed Sacrament Church was designed by Charles R. Greco and built in 1917 on Centre Street between Creighton and Sunnyside Streets. The church is impressive, having been influenced by the Papal Basilica of Saint Paul Outside the Walls in Rome, with two monumental Ionic columns supporting a dentil pediment and an impressive octagonal dome that can be seen from many vantage points. The church was suppressed in 2004 and sold to the Jamaica Plain Neighborhood Development Corporation and New Atlantic Development in 2005. The original wood frame church, which was dedicated in 1892, can be seen on the left.

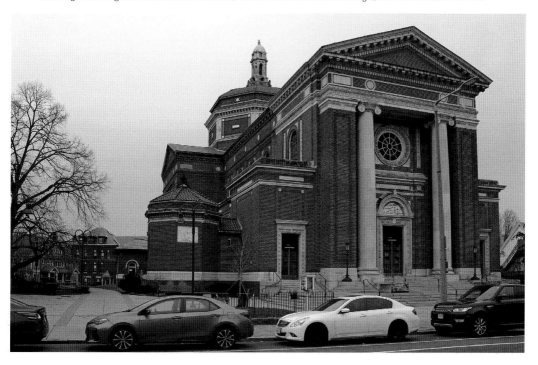

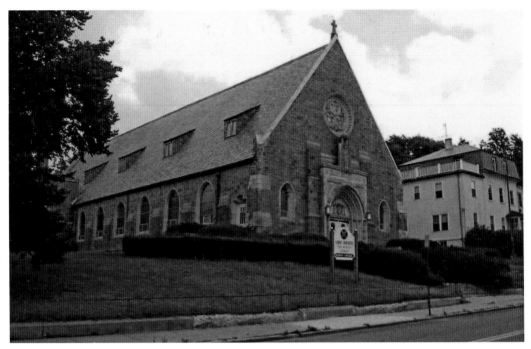

St. Andrew the Apostle Church was designed by O'Connell and Shaw and built in 1918 in the English Revival style of Weymouth seam-face granite at the corner of Walk Hill and Wachusett Streets. St. Andrew's parish was established in 1918 from sections of St. Thomas Aquinas and Roslindale's Sacred Heart Churches. Walk Hill Street, originally known as the Old Road, was laid out in 1806 connecting Dorchester to Jamaica Plain. The church closed in 2000 and the Bethel African Methodist Episcopal Church now worships here.

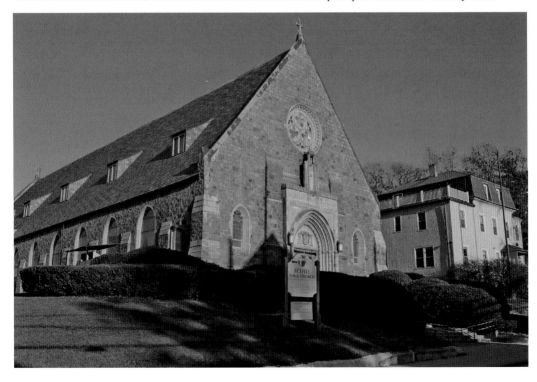

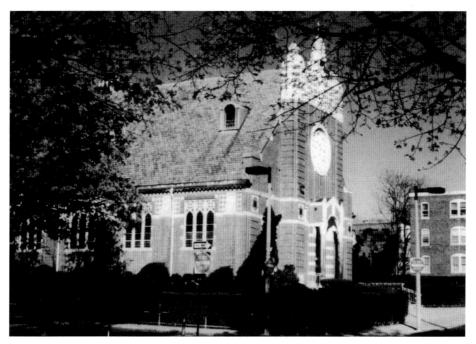

Our Lady of Lourdes Church was designed by Edward T. P. Graham and built in 1931 at 14 Montebello Road and named in honor of the Marian apparitions witnessed by Bernadette Soubirous, her sister, Toinette Soubirous, and neighbor, Jeanne Abadie, that occurred in 1858 in the vicinity of Lourdes in France. Originally established in 1908 on Brookside Avenue as a mission of St. Thomas Aquinas, this new and larger church in the Tuscan Romanesque style with stringcourses of alternating brick and limestone was built for the growing parish.

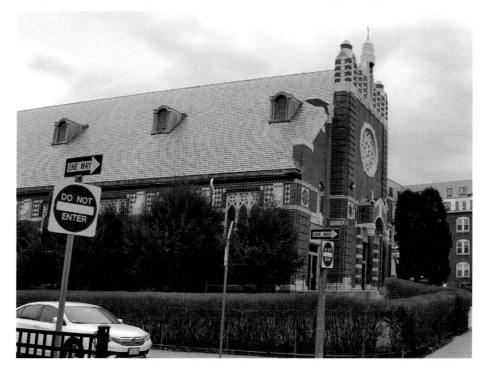

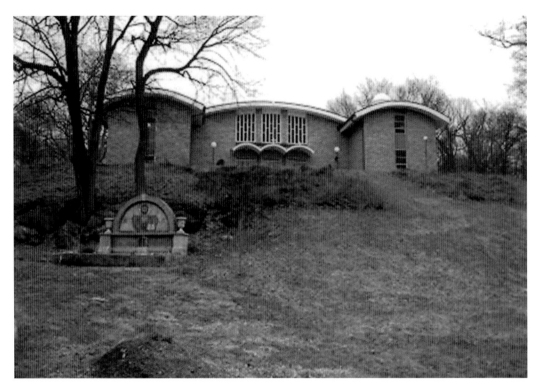

Christ the King Ukrainian Catholic Church was built in 1972 at 118 Forest Hills Street. Moving from the Holy Trinity Church in Boston, the Ukrainian Catholic parish acquired the M. Denman Ross Estate in Forest Hills from the City of Boston, with the proviso that the land could only be used for parochial purposes and that if the parish ever decided to relocate, the church and land would have to return the land to the city. The church is a modernistic 400-seat structure which incorporates many Ukrainian architectural features and mosaics.

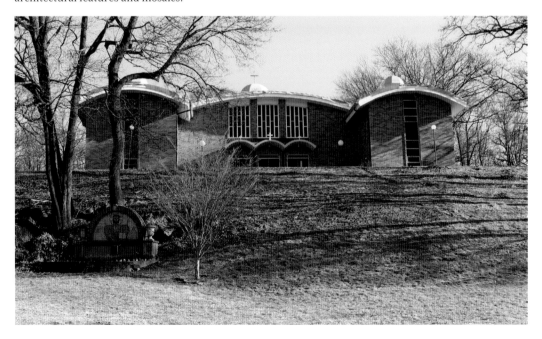

4

SCHOOLS

English High School was founded in 1821 at the urging of the Massachusetts Charitable Mechanics Association to educate working-class schoolboys in preparation for business, mechanics and engineering trades as the "aim of every English High School boy is to become a man of honor and achievement." The original curriculum consisted of such courses as English, surveying, navigation, geography, logic and civics as well as a strong emphasis on mathematics. Boston English became coeducational in 1972 and today is located at 144 McBride Street in Jamaica Plain and the motto of the school is "Honor, Achievement, Service to Mankind."

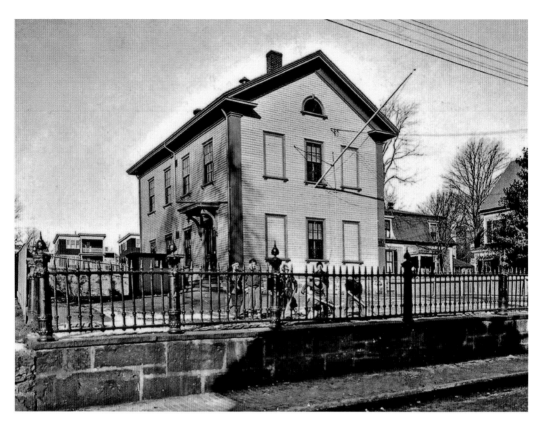

The Chestnut Avenue Primary School was a small two-room wood frame school on Chestnut Street just north of Boylston Street. This small school offered a sound basic education for the first three grades in reading, writing and arithmetic along with an elementary understanding of other subjects. Laid out in 1848, Chestnut Avenue connects Centre Street and Green Street, running parallel to the Stony Brook.

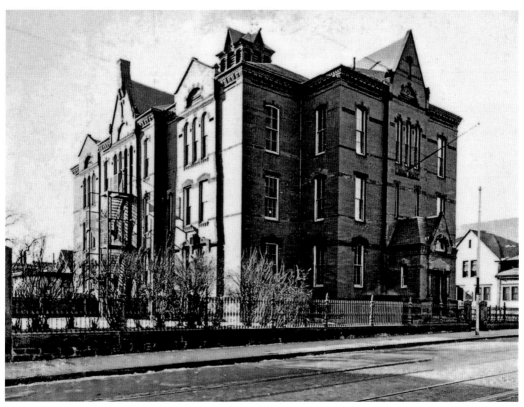

The John Lowell School was built in 1874 at the corner of Centre and Mozart Streets. John Lowell (1824-1897) was a United States Circuit Judge of the United States Circuit Courts for the First Circuit and previously was a United States District Judge of the United States District Court for the District of Massachusetts. The Lowell Family once lived at their country estate *Bromley Vale* in Jamaica Plain which had been owned by his grandfather Judge John Lowell and his father John Amory Lowell. Demolished in the 1950s, the school site is now the Mozart Street Playground.

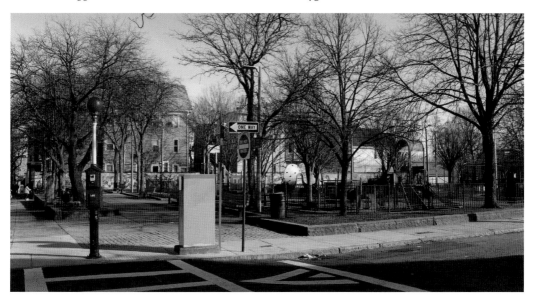

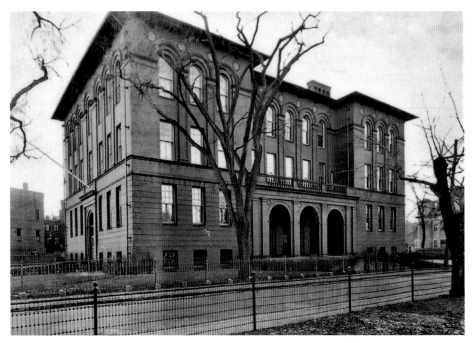

The Agassiz School was designed by Edmund March Wheelwright and built in 1892 at the corner of Brewer and Burroughs Street. Jean Louis Rodolphe Agassiz (1807-1873), for whom the school was named, was a naturalist and professor at Harvard College of Zoology and Geology from 1848 to 1873. He was the founder of Harvard's biological sciences and its Museum of Comparative Zoology, and one of the founders of the National Academy of Sciences. His second wife was Elizabeth Cabot Cary Agassiz, who in 1882 founded the Society for the Collegiate Instruction of Women, which later became Radcliffe College. The Agassiz School was closed in 2011 and became the Mission Hill K-8 School and the Margarita Muñiz Academy, the state's first public two-way bilingual high school.

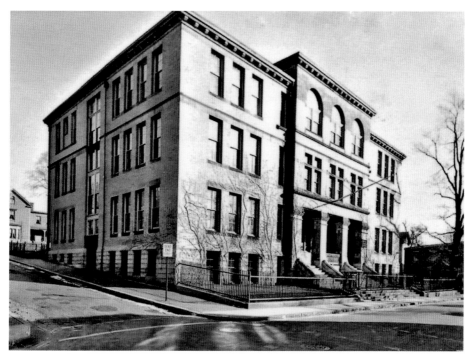

The Nathaniel Bowditch School was designed by Harrison Henry Atwood, city architect of Boston, and built in 1892 at 82 Green Street. The three-story brick and granite Classical Revival school was named for Dr. Nathaniel Bowditch (1773-1838), the founder of modern maritime navigation. His monumental book *The New American Practical Navigator*, first published in 1802, is still carried on board every commissioned United States Naval vessel. The school was listed on the National Register of Historic Places in 1990 and has been remodeled for use as the Paul Sullivan Housing/ Pine Street Inn.

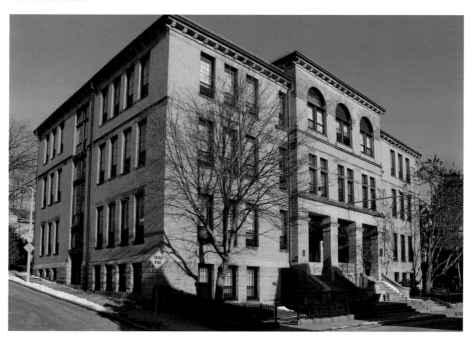

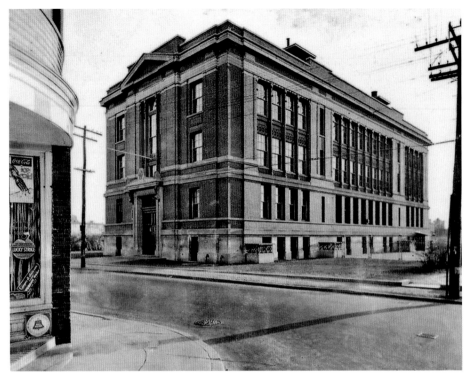

The Jefferson School was built in 1910 at 240 Heath Street and named for Thomas Jefferson (1743-1826), the third president of the United States. Since 1990 this had been the Jefferson Schoolhouse Condos and in 2010 World Tech Engineering, LLC was awarded the design and construction administration of a building envelope restoration project. Heath Street, which extends from Centre Street to South Huntington Avenue, was laid out in 1825 and named for Major General William Heath, a member of the Provincial Congress of 1774 and who served in the Continental Army during the American Revolution.

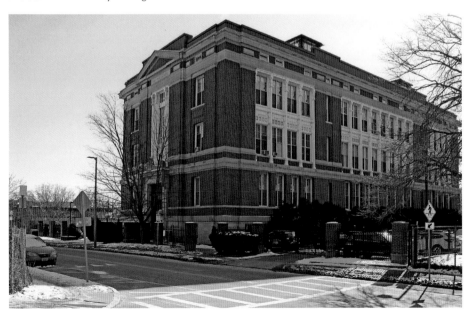

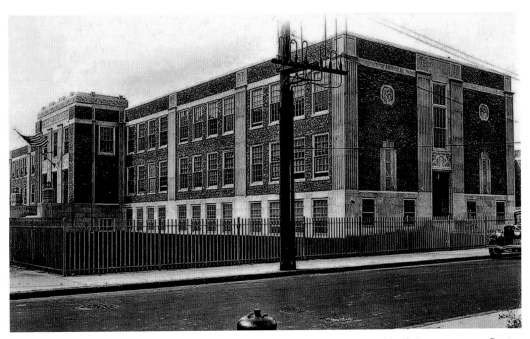

The Mary E. Curley School was designed by McLaughlin and Burr and built in 1931 at 493 Centre Street at Pershing Road; the school is a restrained Art Deco design of red brick and cement. The school is named for Mary Emelda Herlihy Curley (1883-1930,) the first wife of the mayor of Boston, James Michael Curley, who was in office from 1930-1934. Mrs. Curley was active in charitable and civic causes and was a respected member of the community. Today, the school is known as the Curley K-8 School and combines both the Mary Curley School and the James Michael Curley School.

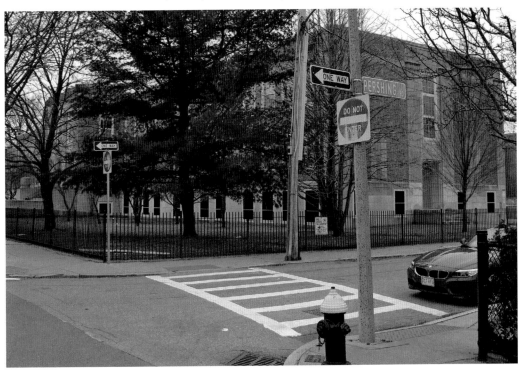

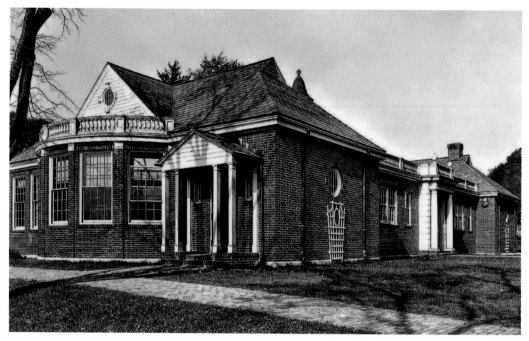

The Edwin Pliny Seaver School was designed by Blackall, Clapp and Whittemore and built in 1924 at 35 Eldridge Street. Edwin Seaver (1838-1917) was a tutor at Harvard College, where he also served as assistant professor of mathematics from 1865 to 1874. He was appointed headmaster of the English High School in Boston, and held the position from 1874 to 1880, after which he served as superintendent of public schools from 1880 to 1904. He was the coauthor with George Walton of *The Franklin Elementary Arithmetic*. In 1983, the school was converted to condominiums by the Finch/Abbey Group.

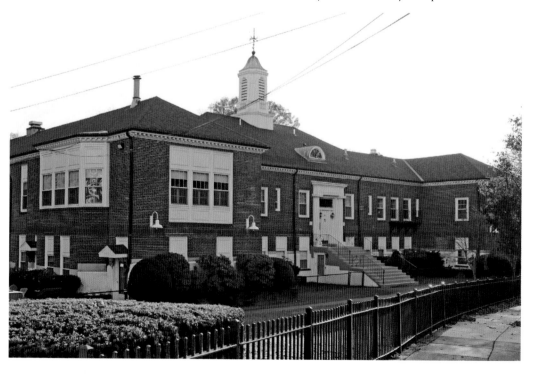

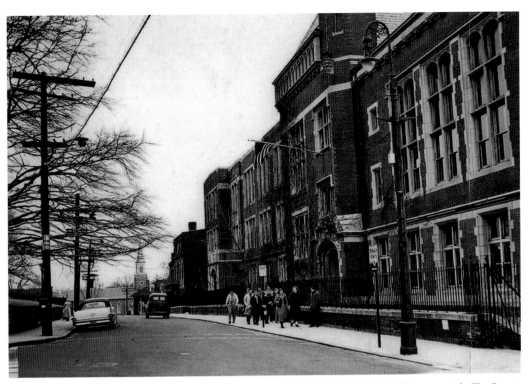

Jamaica Plain High School was designed by Andrew, Jacques and Rantoul and built in 1901 at 80 Elm Street. Originally built as the West Roxbury High School, and later renamed the Jamaica Plain High School, the high school of the town of West Roxbury which included not only West Roxbury but the neighborhoods of Jamaica Plain and Roslindale. Even after the town was annexed by Boston in 1874, it still served all of Jamaica Plain, Roslindale and West Roxbury and its concentration since 1918 was on vocational agriculture. The Jacobean style red brick and limestone school has been remodeled as condominiums.

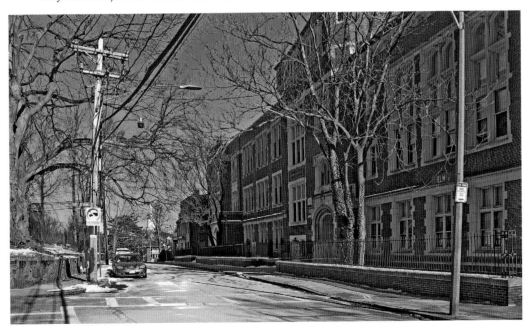

5

HOSPITALS, INSTITUTIONS & CLUBS

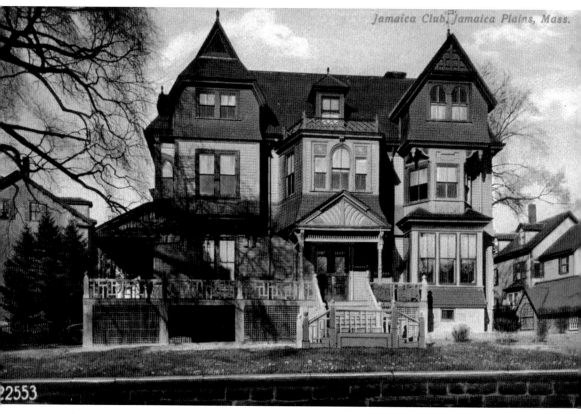

Jamaica Club, Jamaica Plains, Mass.

The Jamaica Club built their clubhouse in 1889 at the corner of Green and Rockview Streets. A large house with flanking gables and Stick Style detailing was designed by John A. Fox. It was a rambling series of rooms where club members could play billiards, card games and socialize as it was a popular place patronized by local residents. The clubhouse was shaded by an ancient elm tree known locally as the Jamaica Elm, which was thought to be one of the largest trees in Massachusetts in the early twentieth century. In 1918, the Jamaica Plain Council, Knights of Columbus, a fraternal service organization committed to faith in action, bought the clubhouse; used as a meeting hall, it also had junior members of the club known as squires and squirettes. Today, a modern building is on the site.

Eliot Hall is at 7 Eliot Street. The Footlight Club, founded in 1877 and said to be America's oldest community theatre, still presents performances in the hall to the delight of Bostonians. Originally built in 1832, the Greek Revival style hall was slated for demolition by the time the club's members purchased it in 1889. Since then, it has served as the organization's home and performance venue. Eliot Hall is used as the offices and performance space of The Footlight Club, and is often rented out by the club for private events including the once famous Miss Souther's Dance Class in the mid-twentieth century. In 1988, the hall was added to the National Register of Historic Places.

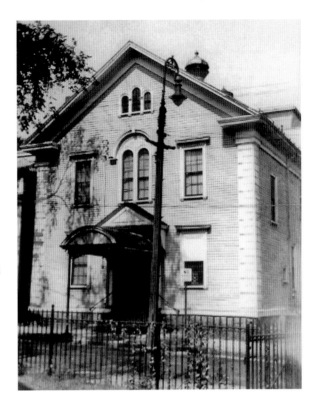

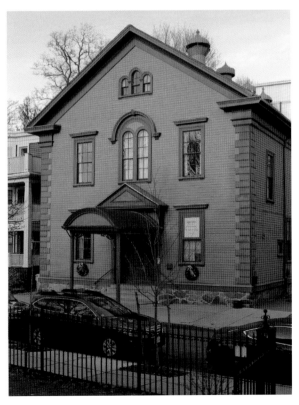

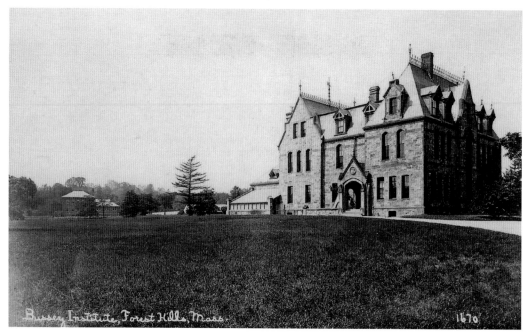

Named for Benjamin Bussey, a horticulturalist who made significant contributions to the creation of the Arnold Arboretum, the Bussey Institute was established "for instruction in agriculture, horticulture, and related subjects." Harvard used Bussey's estate *Woodland Hill* for the location of the Bussey Institute, which was dedicated to agricultural experimentation. The first Bussey Institute building was completed in 1871 and served as an undergraduate school of agriculture. James Arnold, who made a large bequest to Harvard, specified that a portion of his estate was to be used for "the promotion of Agricultural, or Horticultural improvements." In 1872, when the trustees of the Arnold will transferred his estate to Harvard University, Arnold's gift was combined with 120 acres of the former Bussey estate to create the Arnold Arboretum.

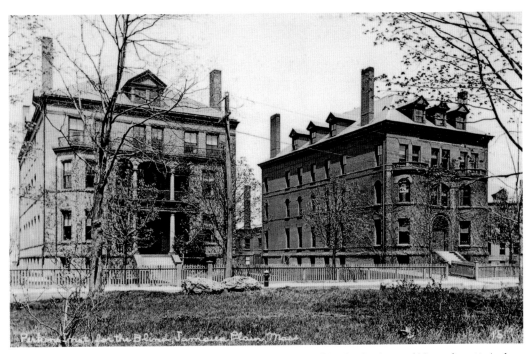

The Perkins School for the Blind, founded in 1832 as the Perkins Institution and Massachusetts Asylum by Dr. Samuel Gridley Howe, opened a "Kindergarten for the Blind" at Hyde Square in Jamaica Plain in 1893. Located at the corner of Day and Perkins Streets, the school had two buildings, designed by Walter R. Forbush, once associated with Amos Porter Cutting, and segregated by sex. The school prepared blind children under the age of nine for a lifetime of self-respect and to be self-supporting members of society. Dr. Howe also originated new teaching methods, as well as the process of printing books in Braille.

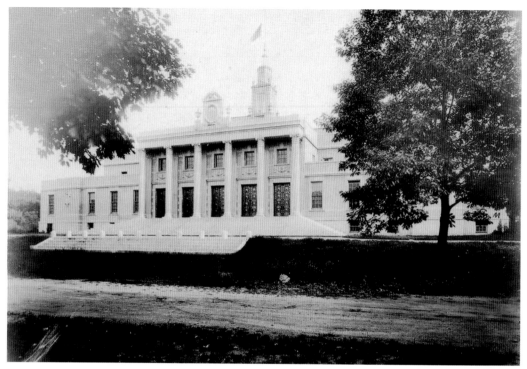

The West Roxbury Municipal Courthouse was designed by O'Connell and Shaw and built in 1923 at 445 Arborway; the court houses the Boston Municipal and Juvenile Courts and serves the neighborhoods of Hyde Park, Jamaica Plain, Roslindale, West Roxbury, parts of Mattapan, and parts of Mission Hill. An elegant building with an Ionic columned façade and flanking wings and surmounted by a cupola, it was extensively remodeled by Elkus/Manfredi Architects in 1994.

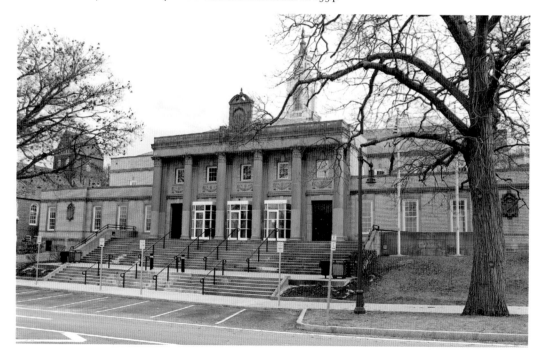

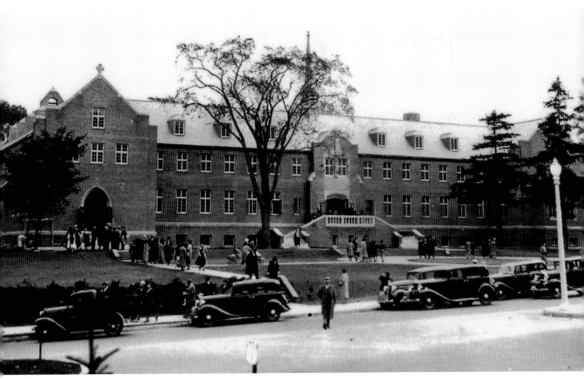

The Monastery of St. Clare was designed by Edward T. P. Graham and built in 1929 at 920 Centre Street at the Jamaicaway Rotary. Operated by the Poor Clare Nuns of the Franciscan Monastery of St. Clare, the order was founded by Clare of Assisi and they are members of a contemplative order of nuns in the Catholic Church. They came to Boston's Chinatown in 1906 and they would build this monastery in 1929 in Jamaica Plain. The Holy Name Federation of Poor Clare Nuns was formed in 1960.

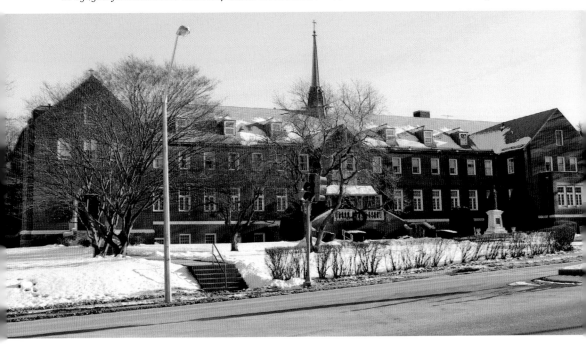

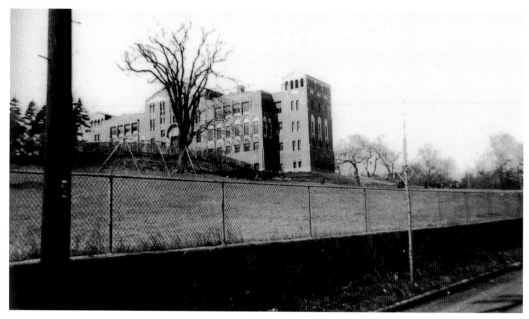

The Italian Home for Children is located at Centre Street and Westchester Road. Incorporated in 1919 as the Home for Italian Children, it was the influenza epidemic of 1918 which orphaned many Italian children of Boston's North End, and the community and clergy responded by establishing the home to care for the orphans. A ten-acre lot was purchased in Jamaica Plain in 1920 and in 1927, a large building was constructed. Today, the Italian Home for Children is a multi-racial, multi-cultural children's organization that provides services for the most severely abused, neglected and emotionally disturbed children.

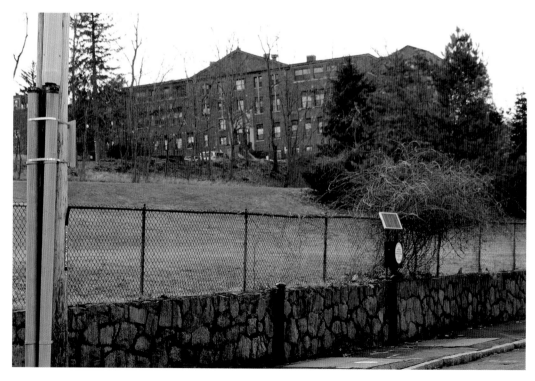

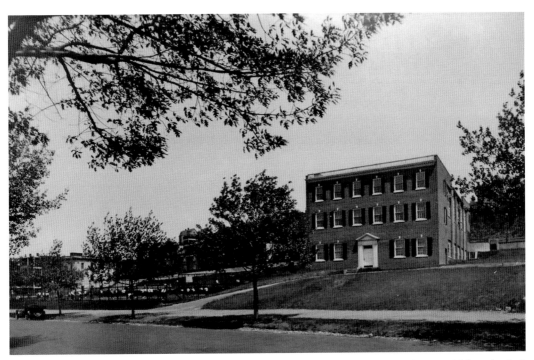

The Boston School of Physical Education was at 105 South Huntington Avenue. It was said that physical education professionals regarded "Bouvé girls," named for director Marjorie Bouvé, as exemplary candidates for teaching positions and that "the school proposes to graduate only such students as will make good teachers and who are qualified to carry forward and maintain the highest ideals." The North American Indian Center of Boston is now located here and is beside "Serenity," designed by David Chilinski of Prellwitz Chilinski Associates as an apartment high rise.

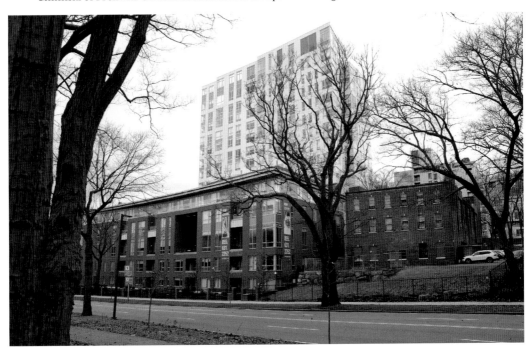

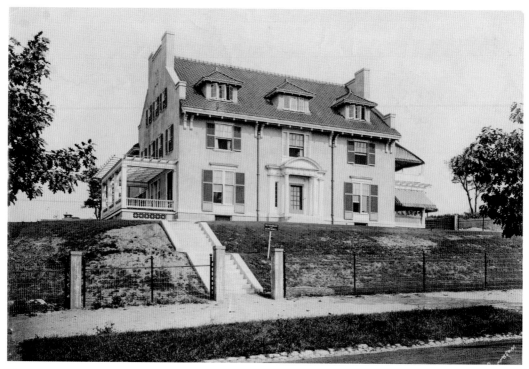

The Boston Nursery for Blind Babies was designed by Oscar A. Thayer at 147 South Huntington Avenue and built in 1911. Founded in 1900 and originally on Fort Hill in Roxbury, the stucco and red tile roofed house was a place where doctors were often able to restore the sight of the young children through surgeries or improved nutrition. The nursery greatly helped the children, offering specialized services with greater levels of need, teaching them to speak, walk, eat and clean themselves. Once the children turned five, they were sent on to the Perkins School for the Blind located at Hyde Square. The nursery closed in 1995 and reorganized itself as the Boston Center for Blind Children.

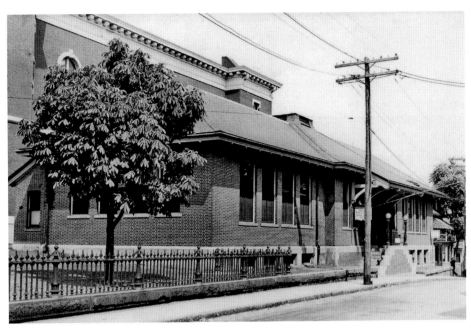

The Jamaica Plain Branch of the Boston Public Library was originally opened in 1876 as a reading room in adjacent Curtis Hall, the former town hall of West Roxbury, and it grew as Jamaica Plain greatly expanded following its annexation to Boston in 1874. The present library was opened in 1911 as a long, one-story red brick library at 12 Sedgwick Street. In 2017, a renovated and new addition by Utile, an architectural firm that states they "thrive on solving complex urban problems in intelligent, pragmatic ways," was designed as a 2,500-square-foot addition as a modern complement to the original library, with a bold angular entryway of glass.

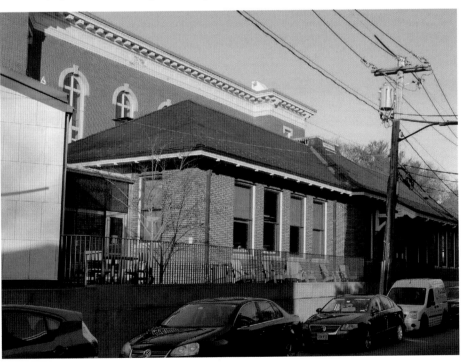

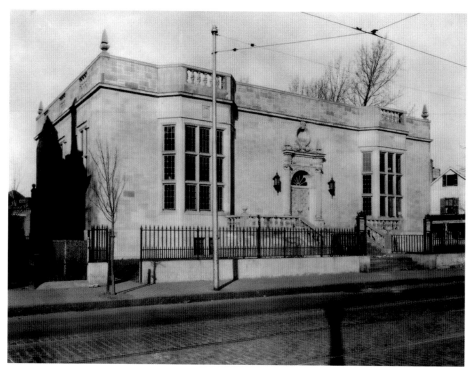

The Connolly Branch of the Boston Public Library was originally known as the Boylston Station Reading Room, named for the Boylston Depot of the Boston and Providence Railroad. The present library was designed by Maginnis and Walsh, with a Jacobean inspired facade, and built in 1932 at 433 Centre Street near Hyde Square. The library was named for Right Reverend Monsignor Arthur T. Connolly (1853-1933), a one-time president of the Boston Public Library Board of Trustees and pastor of the Blessed Sacrament Church.

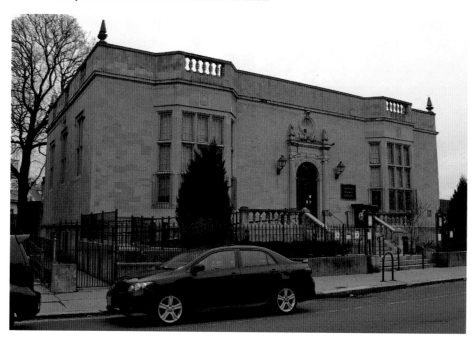

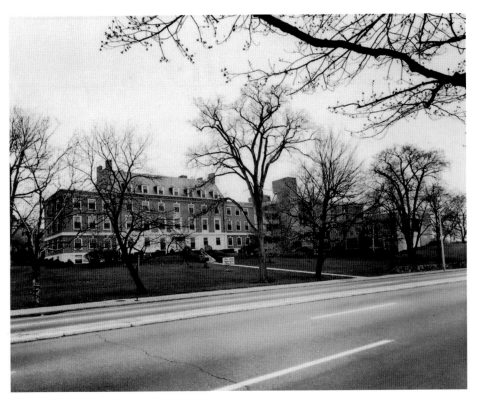

Faulkner Hospital, named for Dr. George Faulkner (1819-1911) and located at the corner of Centre and Allandale Streets, was opened in 1903 to serve the medical needs of local residents. Chapin House, named for president and board member Henry Bainbridge Chapin, was built in 1926 as the nurses' home. It was demolished and a new building designed by Peterman Architects as a five-story building constructed of precast concrete containing three floors of private practice physician suites, a conference center and cafeteria on the second floor, and a new main lobby and reception area on the ground level.

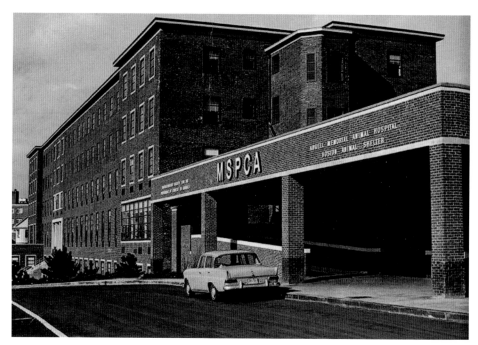

Founded by George Thorndike Angell (1823-1909) in 1868, the Massachusetts Society for the Prevention of Cruelty to Animals (MSPCA-Angell) is a veterinary hospital, shelter and adoption center for animals. Their newsletter *Our Dumb Animals* was the first magazine "to speak for those who cannot speak for themselves" and after many years, the MSPCA and Angell moved in 1976 to a new home at 350 South Huntington Avenue which was formerly the Cardinal O'Connell Junior Seminary. In 2006, a new Boston facility was opened, which includes the Helen Schmidt Stanton Clinical Care Center and the Copeland Animal Care and Adoption Center.

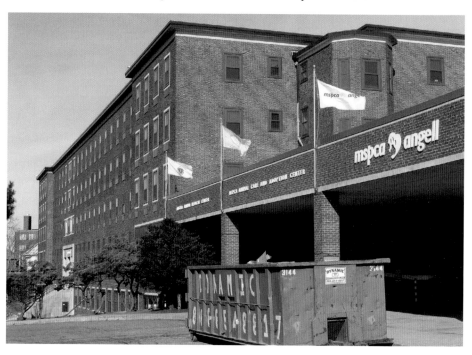

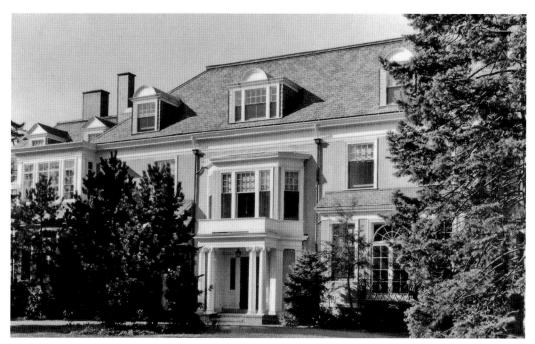

The Children's Museum was founded in 1913 by the Science Teachers' Bureau who not just encouraged children to interpret objects but in "training the plastic minds of children to observe accurately and think logically." Once located at *Pinebank*, the former Perkins Estate designed by Sturgis and Brigham, the museum moved in 1936 to the former home of George Wade Mitton, president of Jordan Marsh from 1916 to 1930, at 60 Burroughs Street and remained there until 1979 when it relocated to Museum Wharf at Fort Point Channel, designed by Cambridge 7, and the old museum developed into condos by Moritz Bergmeyer Associates. The mission of the museum is to engage children and families in joyful discovery experiences that instill an appreciation of our world, develop foundational skills, and spark a lifelong love of learning.

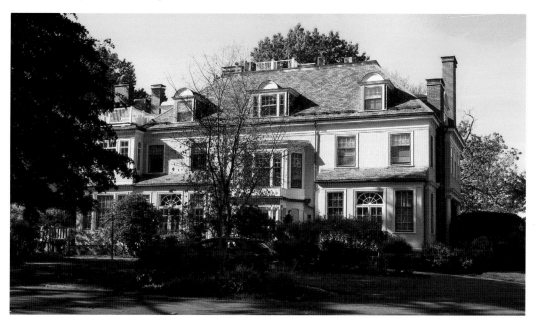

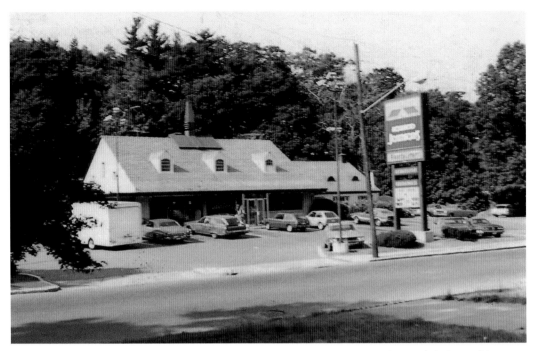

Howard Johnson's Restaurants were founded in 1925 by Howard Deering Johnson (1898-1972) in Wollaston, Massachusetts, and were attractive white Colonial Revival restaurants, with eye-catching orange porcelain tile roofs, illuminated cupolas and sea blue shutters. They were described in *Reader's Digest* in 1949 as the epitome of "eating places that look like New England town meeting houses dressed up for Sunday." This restaurant was at Morton Street and Yale Terrace in Jamaica Plain, and today is the site of the Franklin Park Villa Co-op Apartments.

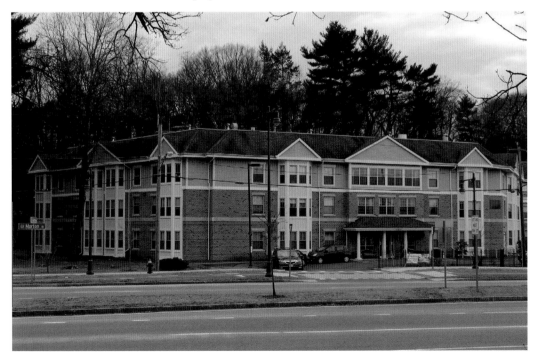

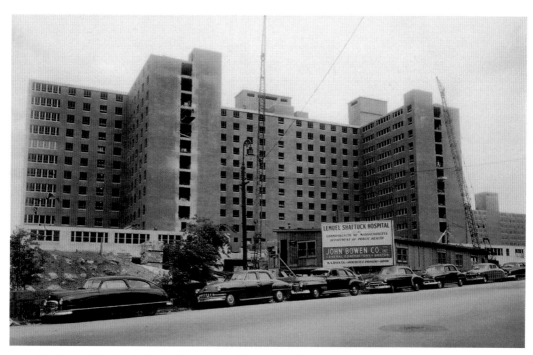

The Lemuel Shattuck Hospital was opened in 1954 at 180 Morton Street and is a 255-bed public health and teaching hospital. Lemuel Shattuck (1793-1859,) for whom the institution is named, played a role in creating America's first board of public health. The hospital's services help economically and socially disadvantaged patients to get high-quality, cost-effective care from a staff that respects their dignity. The Pine Street Inn operates the Shattuck Shelter, previously run by Hopefound, in partnership with the Lemuel Shattuck Hospital. The hospital plans to relocate to the Newton Pavilion in Boston's South End in 2021.

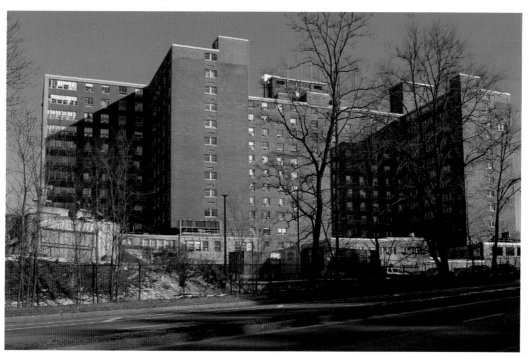

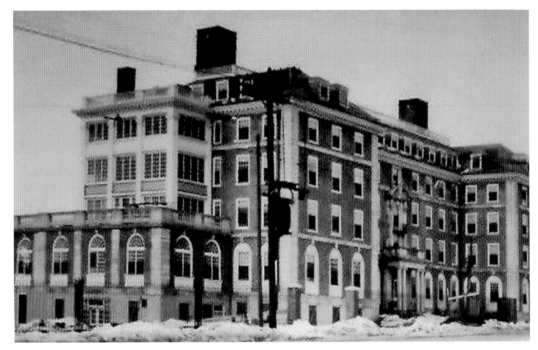

Goddard House was designed by Coolidge Shepley Bulfinch and Abbott and built in 1927 at 201 South Huntington Avenue. Named for Matilda Goddard (1814-1901), a board member from 1850 to 1901, the home was founded in 1849 and is the oldest elder care organization in Massachusetts, and the third oldest in the United States. The mission of Goddard House embraces the aging experience for seniors living in the Boston area by operating a high-quality assisted living community and by creating innovative programs which support our need for purpose, engagement, autonomy and choice as we age. The property is being renovated for Brynx, an upscale apartment complex being designed by Prellwitz Chilinski Associates.

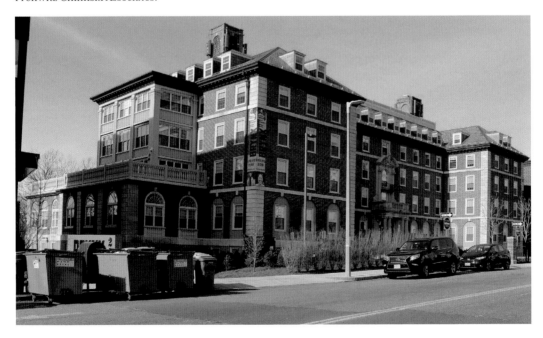

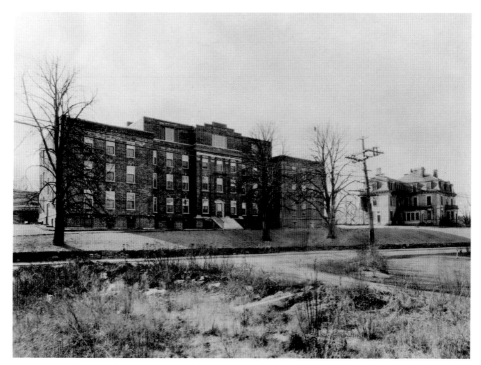

The Washington Hospital moved in 1955 from Waltham Street in Boston's South End to 41 Morton Street in Jamaica Plain. The building formerly housed the Forest Hills General Hospital after which it was the Massachusetts Memorial Hospital and subsequently the Washingtonian Center for Addictions. Today, the former hospital has been converted to condominiums. On the far right is the Emerson Hospital, formerly the home of A. Davis Weld, a homeopathic hospital founded in 1904 and named for Dr. Nathaniel Waldo Emerson (1854-1930) who was the founder and senior surgeon.

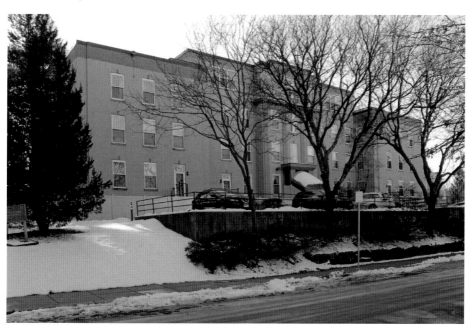

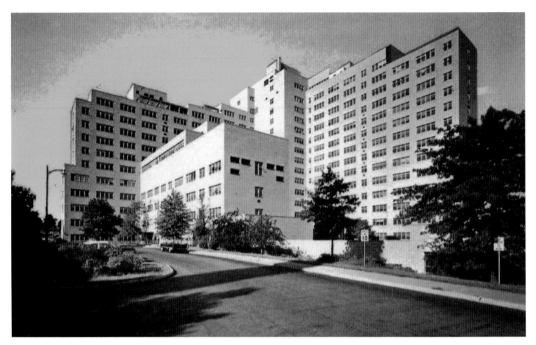

The Veterans Administration Hospital at 150 South Huntington Avenue in Jamaica Plain is run by the United States Department of Veterans Affairs and was opened in 1953. In addition to serving the medical and mental health needs of veterans, the hospital was the site of groundbreaking research in neuropsychology. Edith Kaplan, Norman Geschwind and Harold Goodglass developed many neuropsychological tests here to describe and treat aphasia along with other psychological problems. Today it proudly serves our veterans.

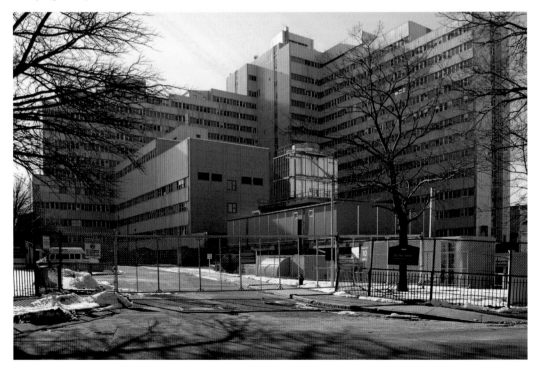

6

BUSINESSES

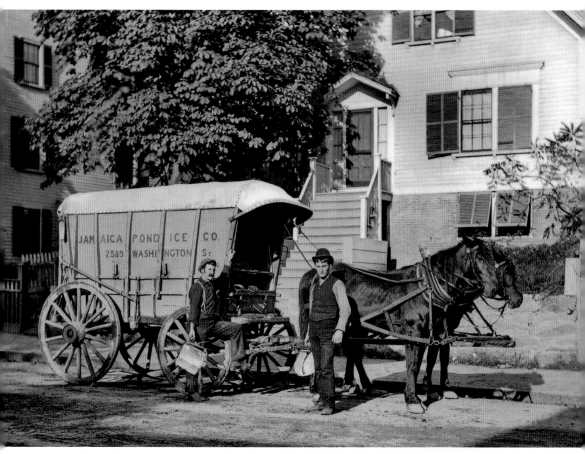

The Jamaica Pond Ice Company delivered ice to local homes and businesses at the turn of the twentieth century when most people kept perishable foods in zinc lined iceboxes. As early as the mid-nineteenth century, after Frederic Tudor had perfected the technique of preserving ice in icehouses, Jamaica Pond provided blocks of ice to cool food and drinks in summer months. In fact, by 1880, twenty-two icehouses stored 30,000 tons of ice along the banks of Jamaica Pond in Jamaica Plain. One left a card in the window alerting the iceman how large a piece of ice was needed for the icebox. These two icemen, seen with blocks of ice held by ice tongs, stand beside their horse-drawn delivery wagon.

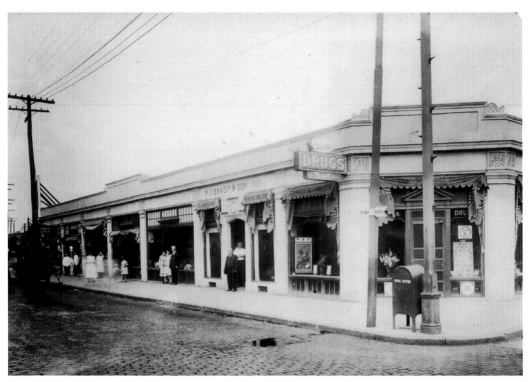

The Brady Block was built at 3721-3722 Washington Street at Forest Hills at the corner of Tower Street. Here the P. J. Brady & Son Funeral Home was located along with the Tower Lunch, the Russo Barber Shop and the McCormack Real Estate Office; on the left are other small shops including the James M. O'Brien Pharmacy on the corner. Brady & Fallon Funeral Home is now located directly behind the block on Tower Street in a modern facility. [*Courtesy of Historic New England*]

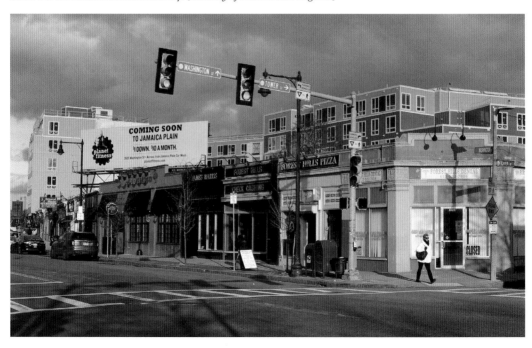

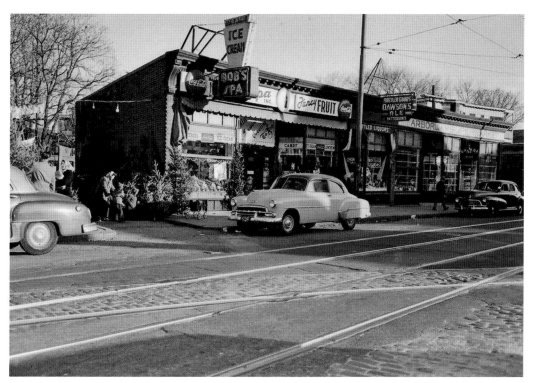

Bob's Spa, once operated by Bob Ristuccia, was at 128 South Street in an early-twentieth-century commercial block that included Dawson's Liquor Shop and the Arborway Supermarket. Bob's Spa was a popular neighborhood store that carried staples and groceries as well as fancy fruit, ice cream and penny candy, and during the holiday season Christmas trees that can be seen on the left of the store in December 1942.

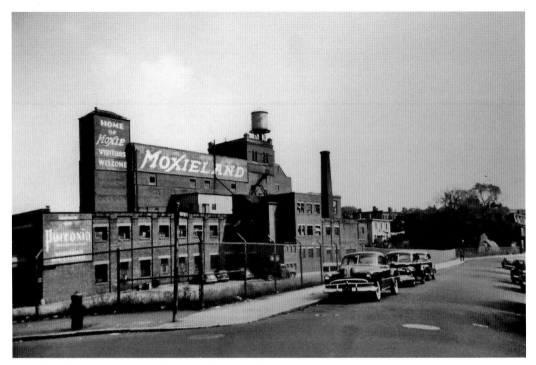

The Moxieland Plant was at the corner of Heath and Bickford Streets, and had a large production and bottling plant for the once famous soft drink. Moxie, a sweet drink with a distinctly bitter aftertaste, originated in 1876 as a patent medicine using gentian root and was called "Moxie Nerve Food," and was among the first mass produced soft drinks in the United States. Between 1928 and 1952 Moxie was bottled at 74 Heath Street and was so popular that it claimed that it helped "recover brain and nervous exhaustion, loss of manhood, imbecility, and helplessness." The plant closed in 1952 when the City of Boston took the land for the Bromley Heath Housing Development, now named the Mildred C. Hailey Apartments.

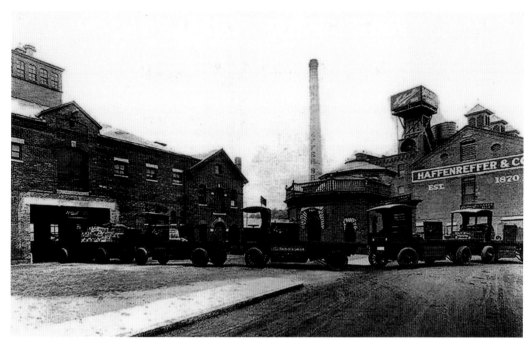

Haffenreffer & Company was a noted brewery that was established in 1870 by Rudolph Frederick Haffenreffer. Operated by three generations of the family, such popular beers as the Haffenreffer Lager Beer, Pickwick Ale, Pickwick Bock Beer and the Haffenreffer Private Stock, a legacy of the original Haffenreffer & Co. product line, were enjoyed by Bostonians from a famous tap that once poured out free beer day and night. The area was bustling, and on many days the smell of hops filled the air. The brewery closed in 1965 after which the Haffenreffer complex was redeveloped by the Jamaica Plain Neighborhood Development Corporation, which operates it today. The Boston Beer Company, brewer of Samuel Adams Beer, has been an anchor tenant since 1984.

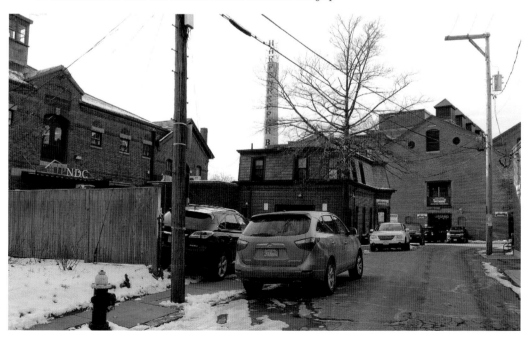

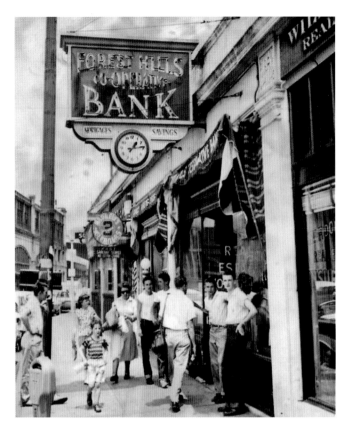

The Forest Hills Co-Operative Bank was opened in 1914 with John S. H. Leard as president and was conveniently located at 3710 Washington Street in Forest Hills; the bank was flanked by William Flannagan Real Estate and Russo Fruit Store and Jacob Russo Barber Shop. A co-operative bank, which is owned by the customers and follows the cooperative principle of one person, one vote, it offered mortgages and loans to the community. Today, the Forest Hills Check Cashing Store is on the site, flanked by the Dogwood Café, Forest Hills Pizza and Forest Hills Dental.

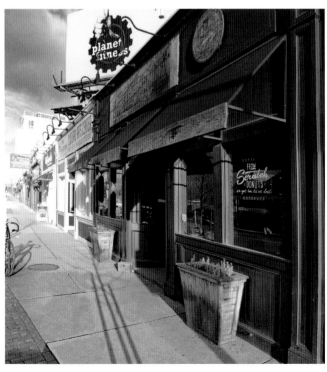

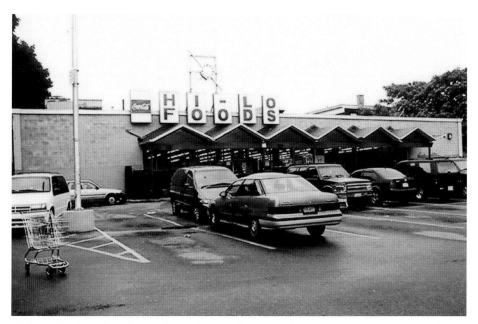

Hi-Lo Foods, which literally translates to "High value, Low prices," was a supermarket at 450 Centre Street in the Hyde Square neighborhood of Jamaica Plain. Knapp Food Group, the Massachusetts-based owners of Hi-Lo, created a well-known and popular source for inexpensive groceries and Latin foods with hard-to-find cookies, produce, sodas, meats and spices from all over the Caribbean and Latin and South America. The almost fifty-year-old supermarket, originally known as Sklars Market, closed in 2011 and was replaced by the Texas based Whole Foods Market.

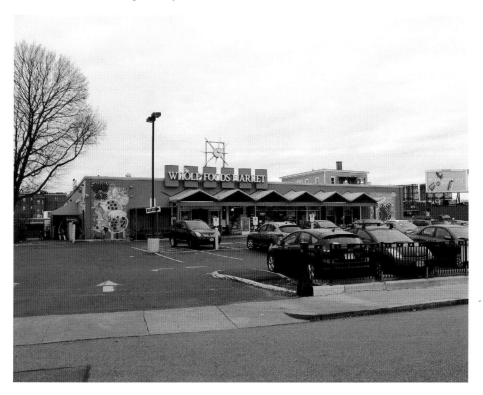

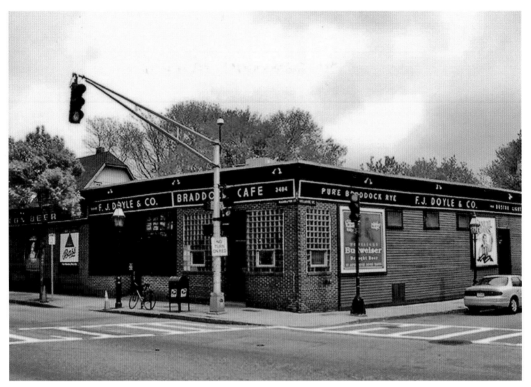

F. J. Doyle & Company was at 3484 Washington Street and had since 1882 dispensed cheer from its Braddock Café. In 1907, then owner Barney Doyle decided to expand his pub to accommodate the burgeoning population of Boston and new residents moving to Jamaica Plain. He then moved the original building from the corner of Williams Street toward Gartland Street. Known as the Braddock Café, in honor of Braddock's whiskey, Braddock's Distillery paid to remodel the facade, which had fallen into disrepair during prohibition and the depression. While the restaurant was popularly known as Doyle's, its formal name, Braddock's Café proudly adorns the front of the building. Doyle's lamentably closed in October 2019.

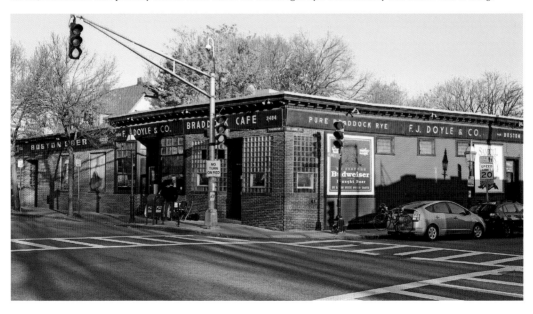

Midway Café at 3496 Washington Street has long been promoted as Boston's Best Live Music and has a loyal following. Since 1987, the café has presented the best acts, and the widest variety of acts, in Boston. From live music, Open Mic Night, Midway or the Highway Comedy, Hippie Hour with the Mystical Misfits, The Peppermints and Hippie Hour with Uncle Johnny's Band, as well as Queeraoke, this is certainly one place that has not just a decided vibe but a devoted following of "creative hipsters."

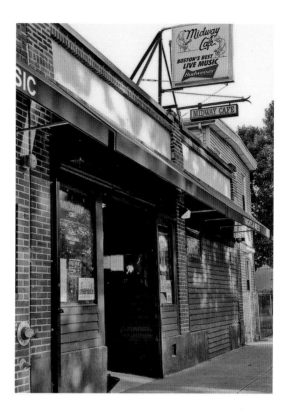

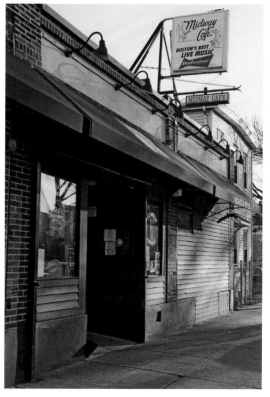

Bella Luna and the Milky Way are at 284 Amory Street and are, as they proudly proclaim these destinations, "a special blend of artsy, inclusive and vibrant." Co-Founders Kathie Mainzer, Charlie Rose, Carol Downs and Pierre Apollon opened the original Bella Luna in 1993 at 405 Centre Street. With good foods as well as live bands, karaoke, comedy and burlesque shows, the business flourished. Deciding to move, a parade of patrons led by Mayor Thomas Menino in 2008 from Hyde Square to The Brewery was attended by 1,000 people who appreciated "a place where any and all people can feel welcome and enjoy going out." Bella Luna and the Milky Way found a new home in the historic Haffenreffer Brewery Complex.

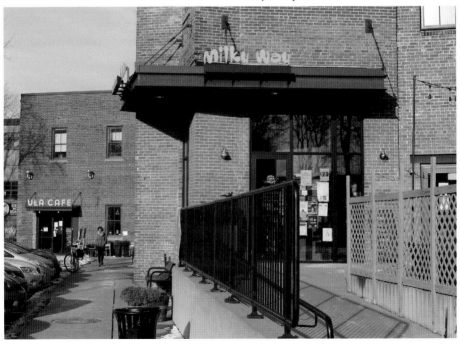

7

RESIDENCES

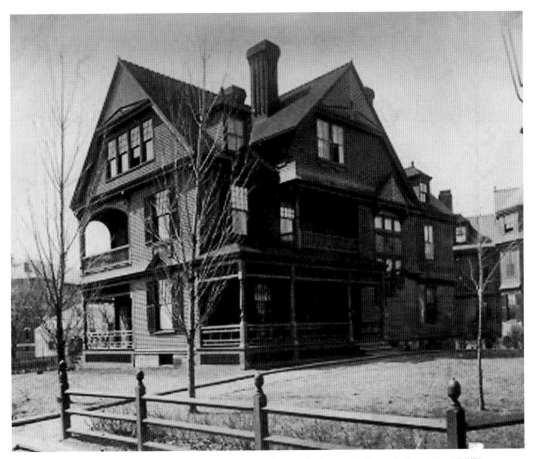

The house of John and Mary Cushing Greenough was designed by the noted architect William Ralph Emerson and built in 1880 on Greenough Avenue on Sumner Hill. Greenough held the position of superintendent of the United States Patent Office from 1837 until 1841, and became wealthy from several profitable patents for shoe-pegging machinery; one of his earliest inventions was a sewing machine and this was the first sewing machine for which the United States Government granted a patent, years before Howe, Singer and Wilson were even on record for a patent. [*Courtesy of Katherine Greenough*]

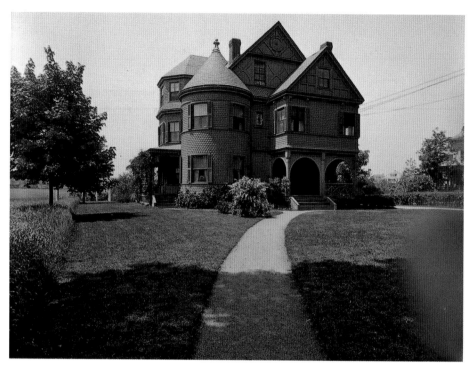

The Charles H. Curtis House is at 509 Centre Street. A large Queen Anne style house with a round bay with a turret and half-timbering facade work, it was built in 1882, incorporating an earlier house dating from 1721 on land that had been owned by the Curtis Family for generations. The Curtis Family were market gardeners and raised fruits and vegetables that were sent to both Faneuil Hall and later Quincy Market through the early twentieth century. The house later became the Gormley Funeral home and is now condominiums designed by Reisen Design Associates; the house is flanked by the East Boston Savings Bank on the left and the Curley K-8 School on the right. [*Courtesy of the Curtis Family*]

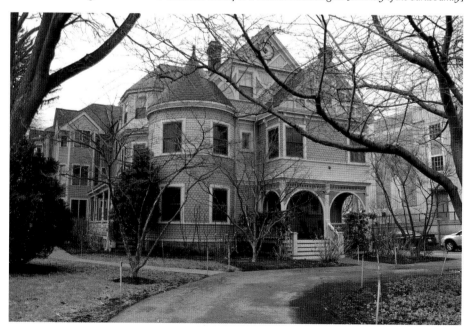

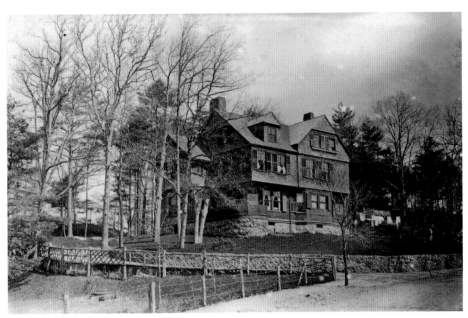

The Wheelwright House was a large Shingle Style house designed by Edmund March Wheelwright (1854-1912) and built in 1884 at Sigourney and Glen Streets for his mother, Hannah Giddings Tyler Wheelwright. Wheelwright had been educated at both MIT and the École des Beaux-Arts in Paris and was considered one of the foremost architects in Boston. Associated with the firms of Peabody and Sterns and McKim Mead and White, in 1890 he and Parkman B. Haven created the firm of Wheelwright and Haven. Wheelwright also served as Boston City Architect between 1891 and 1895. [*Courtesy of Historic New England*]

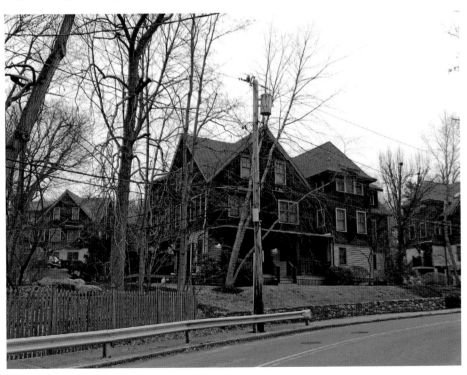

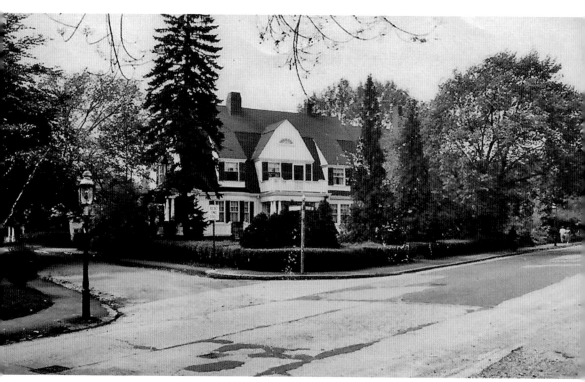

The John B. Fallon Esq. house was designed by Loring and Phipps and built in 1902 at 489 Walnut Avenue, on the corner of Park Lane, opposite Franklin Park. Dr. David D. Scannell bought the house in 1920; he was a graduate of the Harvard Medical School and served as surgeon in chief and president of the staff of Beth Israel Hospital. Scannell was elected a member of the Boston School Committee from 1908-1910, 1914-1916 and 1921-1925, and chaired the Committee in 1916 and 1922. [*Courtesy of Henry Scannell*]

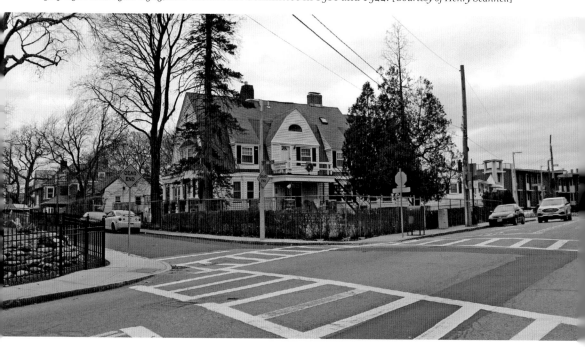

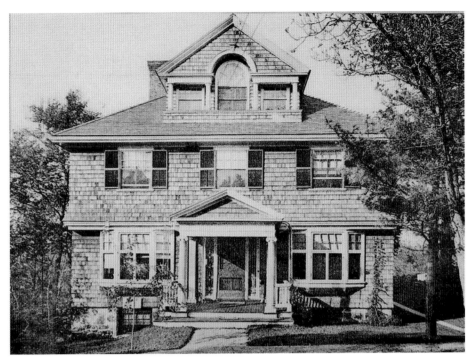

The Benjamin Kimball, Esq. house was designed by Arthur H. Dodd (1837-1901) and built in 1903 at 19 Park Lane. Dodd was a graduate of MIT and was in the 1880s a partner of Frank Maynard Howe; he was also a well-known author and president of the Papyrus Club of Boston. Park Lane, which was originally known as Franklin Park Terrace, is a *cul de sac* off Walnut Avenue and was laid out and developed by local land developer Thomas F. Minton in 1894.

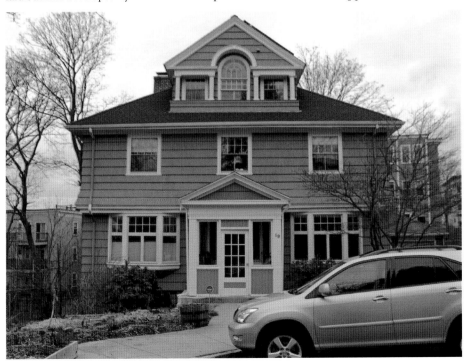

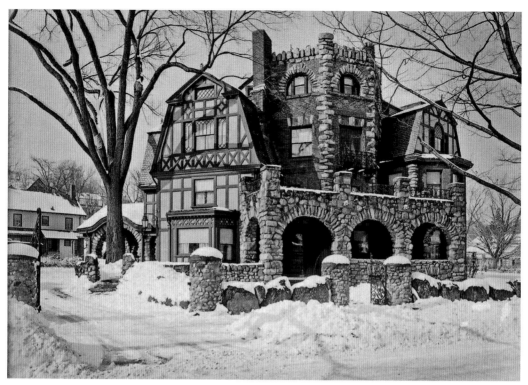

61 Arborway was built in 1897 for Thomas and Isabella May Carter and is often referred to as the "Arborway Castle." The house is a flamboyant amalgamation of stone, brick, half timbering and wood shingles that combine to make this late Victorian mansion incredibly impressive. It is said to have been built in the late nineteenth century around the original house of Captain May, an ancestor of Mrs. Carter, dating from 1650, making the bones of the current castle perhaps the oldest residential house in Jamaica Plain.

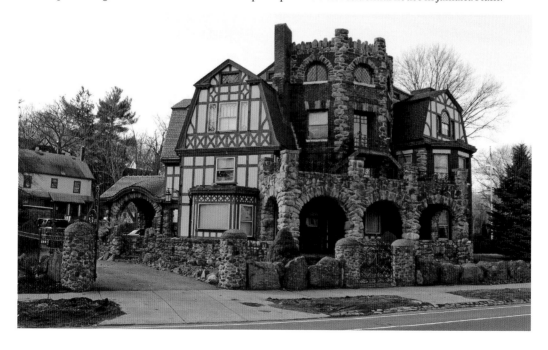

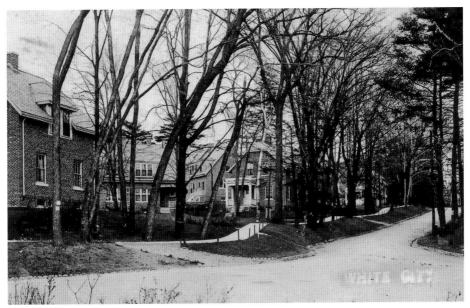

Woodbourne is a housing development of the early twentieth century around the intersection just west of Hyde Park Avenue and Eldridge Street. It derived its name from proximity to the Forest Hills Station on both the Boston & Providence Railroad and the Boston Elevated Railway, with pedestrians and motorists from all directions passing the development. Seen on the left is 33 Southbourne Road, a red brick house typical of this charming enclave of houses. Now known as the Woodbourne National Register District, the garden city setting was developed, and many houses were designed by Mulhall & Holmes, Woodbury & Stuart and James G. Hutchinson, creating an attractive neighborhood near Forest Hills.

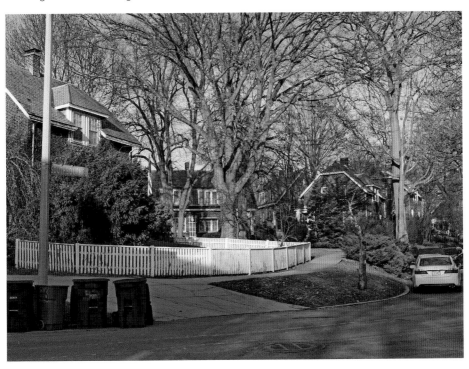

The James Michael Curley House was designed by Joseph P. McGinnis and built in 1915 at the corner of the Jamaicaway and Moraine Street, across from Jamaica Pond. A Georgian Revival mansion of twenty-one rooms that was reputedly built by contractors currying favor from Mayor Curley, the work was frequently provided *gratis*; the mansion has shamrocks cut into the white wood shutters that boldly proclaim Curley's Irish heritage. Sold in 1956 to the Oblate Fathers by Curley, the George Robert White Fund purchased the house in 1988 and it has been restored and made available for city and community events.

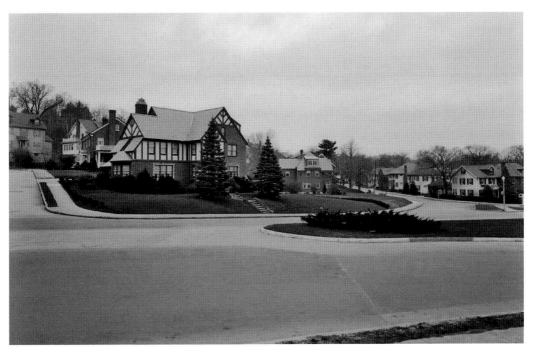

This Tudor Revival red brick and half-timbered house was designed by Robert J. MacDonald and built in 1921 at 1 May Streets at the corner of Hillcroft Road. The area is known as Moss Hill, which was designed by Pray, Hubbard & White Landscape Architects, and has attractive early to mid-twentieth century houses that were the epitome of Boston. The Jamaicaway was designed by Frederick Law Olmsted in the 1890s as the southernmost carriage road in a series of parkways connecting the Emerald Necklace from Boston Common to Franklin Park in Roxbury.

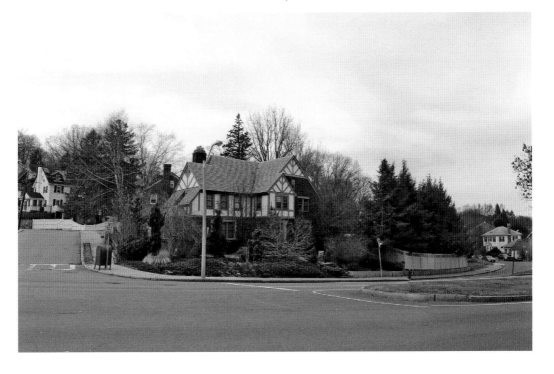

Low-rise apartment buildings were constructed along the Arborway between Forest Hills Station and Forest Hills Cemetery. Built in 1949 by the Boston Housing Authority as red brick three-story flat roofed apartment buildings, they are from the left 495 Arborway and continue west to 461 Arborway. The enclave includes Morton and Forest Hills Streets and Catenaccia and Dunning Way. Today the buildings are known as the Arborway Gardens Condominiums.

8

A STREETCAR SUBURB

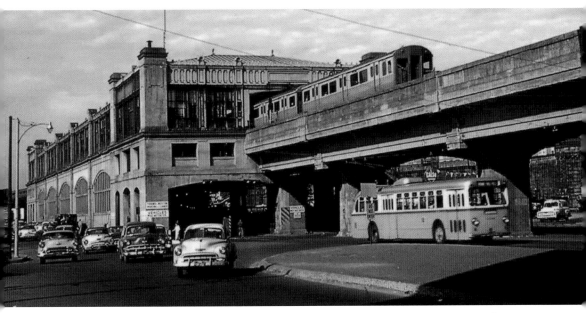

The Boston Elevated Railway, founded in 1894 by Henry A. Whitney, connected Forest Hills in Jamaica Plain to Sullivan Square in Charlestown and created an ease of transportation in the early twentieth century that allowed the train to operate on a timetable as there was no traffic impediments. The first stretch of elevated track was put in service in 1901, between Sullivan Square and Dudley Square in Roxbury and later extended to Forest Hills Station, which was designed by Alexander Wadsworth Longfellow and was opened in 1912, with streetcars bringing passengers to board "the El" from as far away as Dedham.

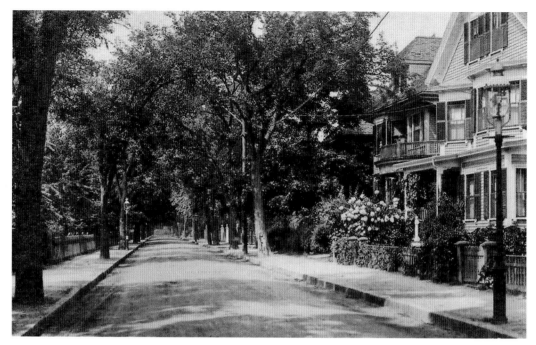

Eliot Street, which was laid out in 1802 and named for Reverend John Eliot (1604-1690), known as the "Apostle to the Indians," connects Centre Street with Pond Street. John Eliot was not the first Puritan to try to convert the Indians to Christianity, but he was the first to produce printed publications for the Indians in their native tongue. In fact, Eliot in 1663 translated the Bible into the Massachusett language and published it as *Mamusse Wunneetupanatamwe Up-Biblum God*. Eliot Street is a charming tree lined street, and it has impressive nineteenth and twentieth century residential architecture, including, on the right, 19 and 17 Eliot Street.

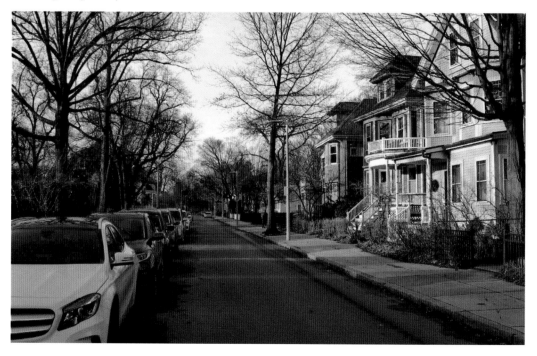

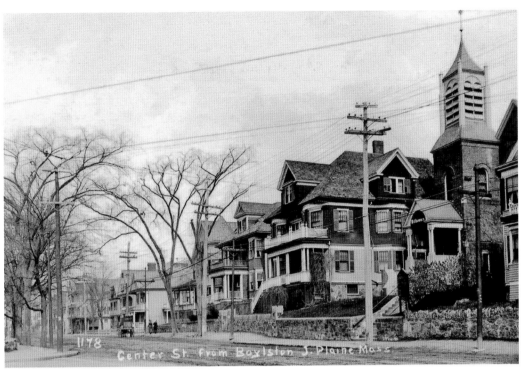

Centre Street, which was laid out in 1662 as the Middlepost Road connecting Boston to Hartford, Connecticut—seen here from the junction of South Huntington Avenue and Boylston Street in 1910—was developed with comfortable two-family Colonial Revival houses set above a stone wall that lined the sidewalk. On the right is the Rock Hill Alliance Church at 440 Centre Street that in 1969 merged with the Christian and Missionary Alliance Church of Brookline. The River of Life Church now worships here.

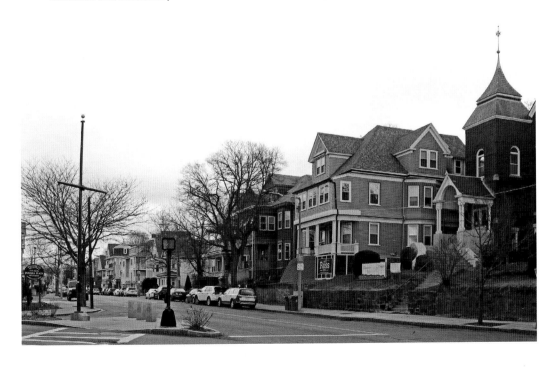

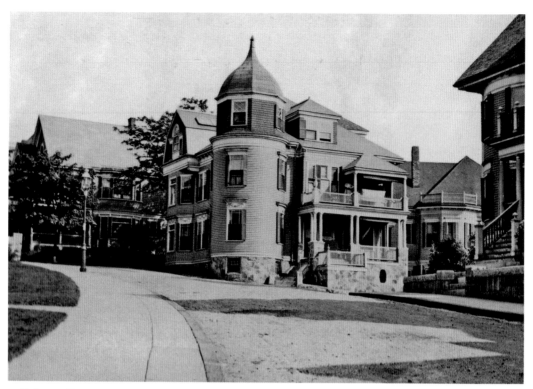

11 Belmore Terrace was designed by Arthur O. Bottomley and is at the corner of Oakview Terrace. A wonderful over-the-top Queen Anne design house verging on the Colonial Revival set on a random ashlar foundation, it has a prominent two-story rounded bay with an octagonal capped roof, swag draped lintels above the windows and a Palladian window in the attic gambrel roof. It is the epitome of a high style and an architecturally significant early twentieth century house in Jamaica Plain. [*Courtesy of Jon Truslow*]

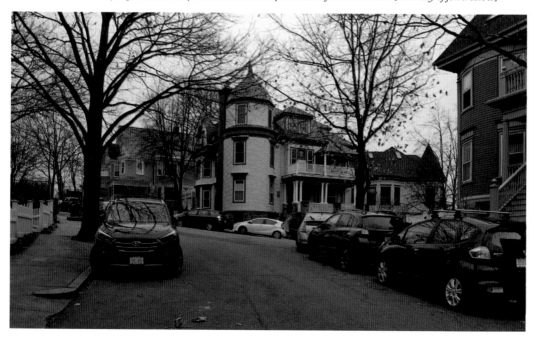

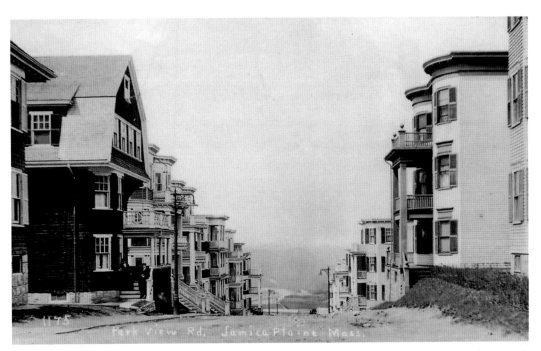

Park View Road, now known as Parkton Road, is a "U" shaped street off Perkins Street that gently descends towards the Jamaicaway and has views of the Emerald Necklace and Willow Pond Meadow beyond. The two-family gambrel roofed house on the left is 8 Parkton Road, designed by James Hutchinson and built in 1911, and on the right is a high style double swell bay facade three decker at 7 Parkton Road, designed by Francis G. Powell and built in 1911. Though both houses are high style and well designed, the lack of zoning often made streets at the turn of the century architecturally incongruous.

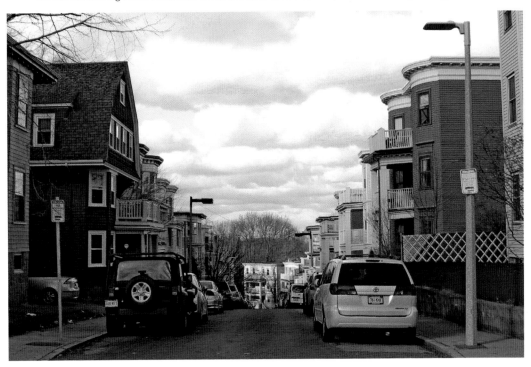

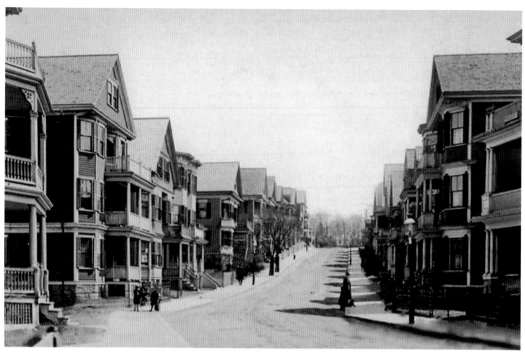

Tower Street, once known as Foley Street, was laid out and developed by local land developer Thomas F. Minton in 1892 and extends from Hyde Park Avenue to a side entrance of Forest Hills Cemetery. The street was developed at the turn of the century with both two-family houses and three-deckers, which line the street. On the left is 17 Tower Street, designed by Murray and Hutchinson Architects and built in 1905 as a double-bay three-decker with Doric columns supporting the front porches and window shutters for shading from the sun.

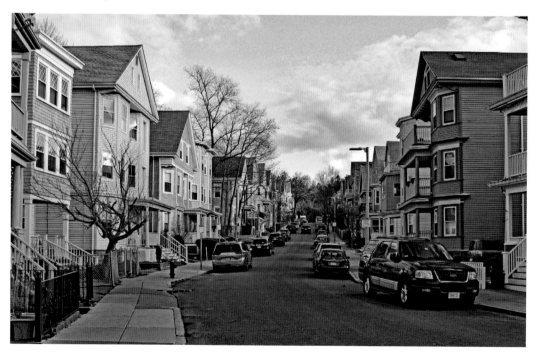